British type specimens before 1831:
a hand-list

Occasional Publication No. 14

JAMES MOSLEY

British type specimens before 1831: a hand-list

Oxford Bibliographical Society
Bodleian Library, Oxford, 1984
in association with
the Department of Typography & Graphic Communication
University of Reading

Published in 1984 by Oxford Bibliographical Society
Bodleian Library, Oxford, in association with the
Department of Typography & Graphic Communication
University of Reading

© *1984 Oxford Bibliographical Society*

ISBN 09 01 420 11 5

Designed and printed in the
Department of Typography & Graphic Communication
University of Reading

Set in Monotype Baskerville series 169 and 313

Contents

Introduction

'A type specimen,' to quote Dr Vervliet, 'may be understood to mean an orderly and preferably complete conspectus of the type-faces available in a particular typefoundry or printing house, offering a choice of types for sale in the one case and for use in the other. It may be a single sheet or a book. The text is of no importance in itself; it serves only to display the types.'[1] The specimen is a catalogue of materials, and, like any catalogue, tends to be discarded when a new edition appears or when its immediate purpose has been served.

Even the most substantial of specimens has generally had the restricted circulation of specialist literature. Daniel Prince, Warehouse-Keeper and Overseer of the Learned Press at Oxford, wrote in 1785 to a correspondent: 'The Specimens of the Oxford University types are not generally given; they are intended to be at hand in the Place, in every College & Library. I have taken the Liberty to send you one, but cannot profess to give them away generally.'[2] In a copy of the Thorowgood specimen of 1821 in the collection of Stephenson, Blake & Co, Sheffield, there is a receipt blank which reads: 'Received of M. One Pound, for a Book of Specimens, which Sum shall be repaid on the Book being returned in good condition, or an Order for Printing Types taken to the amount of £10 and upwards.' Since the specimens of the period covered by this *Handlist* were often broadsides, or pamphlets, stabbed and stitched in wrappers, it is not surprising that only one copy is known to survive of many of them. It also follows, of course, that we can be sure that a substantial number of the specimens printed have either failed to survive or still remain to be discovered. This *Handlist* attempts to list all that are at present known.

Bibliographers, even in the age of Bradshaw and Proctor, were late to grasp the value of type specimens. We owe much to the amateurs (in the fullest sense), such as D. B. Updike and Stanley Morison, who provided the impulse towards that patient study of the surviving typographical materials which has restored to us an accurate knowledge of the work of Claude Garamond, Robert Granjon, Pierre Haultin, François Guyot, Hendrik van den Keere, Christoffel van Dijck and Nicholas Kis, all of them artists whose names were merely legendary or even unknown at the turn of this century. The catalogue compiled by Graham Pollard for the book-selling partnership of Birrell & Garnett in 1928, drawing attention to type specimens as one of 'the sources upon which the scientific study of type design must be based', is the beginning of a heroic age

in the study of the history of printing types. Harry Carter's translation of the *Manuel typographique* of S. P. Fournier appeared in 1930.[3] Work was begun on new editions of Talbot Baines Reed's *History of the old English letter foundries* (1887) and Joseph Moxon's *Mechanick exercises* (1683–4).[4] To this period belongs the suggestion that a series of type specimen sheets, with commentaries, should be published in facsimile,[5] a project realised some twenty years later.[6] Nor was this a movement confined to Great Britain. One of the most poignant examples of a confrontation between the old guard and the new, for the bibliographer, is to be found in the acrimonious controversy surrounding the publication of *Die Typen der Inkunabelzeit* (Berlin, 1928), by Ernst Consentius, who brought a thorough knowledge of the literature and practicalities of typefounding to bear on Konrad Haebler and the theoretical basis of his *Typenrepertorium*.[7] The major monuments of this period, which saw the beginning of the end of the long predominance of the use of metal type as a printing surface, are Morison's *John Fell* (Oxford, 1967) and the new English edition of Charles Enschedé's *Fonderies de caractères et leur matériel dans les Pays-Bas* (1908), completed in 1978.[8]

The *Catalogue of specimens of printing types by English and Scottish printers and founders 1665–1830*, by W. T. Berry and A. F. Johnson, upon which this *Handlist* is based, was published in 1935 in the Oxford Bibliographical Series under the general editorship of Stanley Morison and Graham Pollard.[9] It was based, in its turn, on the lists of type specimens published by Talbot Baines Reed in his *History*, which terminates in 1830. In 1875, William Blades published a plea for the preservation of type specimens,[10] in which he lists examples from his own collection, in the Bagford Collection at the British Museum, and in the library of the American Antiquarian Society at Worcester, Massachusetts. Blades, whose *Life and typography of William Caxton* (1861–3) helped to initiate the study of printing-house practice and its bearing on the transmission of texts which distinguishes the 'new bibliography' of the late 19th century, was the promoter of the Caxton Celebration of 1877. The section of the exhibition and its catalogue on 'Type and other printing materials' was compiled by Talbot Baines Reed, then aged 25, the son of Sir Charles Reed, whose typefoundry had inherited the most substantial collection of early punches and matrices to have survived among the British commercial trade. Reed's interleaved and annotated copy of the section of the catalogue which deals with British type specimens[11] must represent the first attempt to list not only all specimens known to survive but also those merely reported, such as Isaac Moore's Bristol broadside of '1768', which has led a ghostly existence since 1819 until its extinction in the entry for no. **162** in this *Handlist*. The consolidation of these notes in the form of lists at the end of chapters in Reed's *History* provides a

document of great historical importance, since it indicates the owner of each specimen known to Reed in 1887. It is a pity that these lists were omitted from the new edition of 1952, for there are a number of examples of specimens known to Reed that Berry and Johnson fail even to mention in their *Catalogue*. Some of these, such as specimens **93**, **94** and **95**, have happily come to light again, and they have, together with everything else noted by Reed, been restored to this *Handlist*.

Berry and Johnson's invaluable work is advisedly called a *Catalogue*. It aims to describe each specimen in detail, listing a great part of its contents; but, like those of Reed's own work, the descriptions are based almost wholly on acquaintance with a single copy. This is less serious in the case of works printed before the last decade of the eighteenth century. Indeed, it is not invariably true to say, as the compilers do in their prefatory note, that 'type specimen books of the period under review refuse to lend themselves to established [bibliographical] rules'. The specimen books of the Oxford University Press and the early Caslon books are conventionally signed and gathered. After 1800, however, the position is very different. Specimen books then become assemblies of heterogeneous leaves, which seem to have been made up *ad hoc* from such stock as the typefounder possessed or the customer required.[12] The danger to the unwary user of these specimens can be illustrated from many examples in this *Handlist*. Six copies are known of a Figgins specimen book with a title page dated 1815. They have 79, 95, 96, 107, 120 and 124 leaves respectively, and the last two copies, which are the ostensibly most 'complete', include leaves watermarked 1817. Dated price lists and wrappers may give a similar warning that the book has been made up after the date of its title page, but where they are absent, the user must be wary of accepting the title at its face value.

The aim of this *Handlist* is to supply the user of the Berry and Johnson *Catalogue* and its Supplement of 1952 with enough material by way of correction, amplification and updating to enable it to continue to serve, as it has for so long, as one of the essential works of reference in its field.[13] The *Handlist* itself has been regrettably long in the making, but this has been to the user's advantage in one respect. Much material that was unlocated has been gradually tracked down, or alternative copies have been found. Collections that were privately owned are now deposited in the care of institutions where they are as accessible as things of this kind can ever be. Over sixty specimens, most of them unrecorded elsewhere, are listed and located here for the first time.

The *Handlist* follows the division adopted by Berry and Johnson between typefounders' and printers' specimens. Printers who made their own types, such as John Baskerville, are included among the typefounders, and so is the Oxford University Press which ceased

to do so in the early eighteenth century. I have not hesitated to move items from one category to another if their inclusion by Berry and Johnson seemed unjustified.[14]

The Appendixes on pages 55–59 call for some comment. They are designed to include material, some of it listed by Berry and Johnson, which did not seem to fit any strict definition of a British type specimen although it had been somewhere so described. Using this expedient, it has been possible to place in this *Handlist* all the items described by Berry and Johnson, save one.[15] I must emphasise that, while the lists of type specimens are as comprehensive as they can be, no attempt has been made to include all the items that might have been listed in Appendixes i and ii: Reed's *History* alone will supply many more examples. Nevertheless, it seemed worth including an index entry that would lead to, for example, Ritchie and Sammells's *Caesar* of 1790 (**A8**), one of the few acknowledged examples of the roman types of Joseph Jackson, and for Stower's *Printer's price book*, 1814 (**A13**), which performs a similar service for Robert Thorne's later text types.

In his introduction to the Birrell and Garnett catalogue, Graham Pollard cites two complementary sources, in addition to type specimens, for the historian of printing types. There are, in the first place, the archives of printers and founders. These, where they survive, are still 'largely in manuscript, uncalendared and unknown'; but it seems all too likely that many, including virtually the whole of the archives of the foundries of Figgins, Caslon, and Miller and Richard, may have disappeared since the date when Pollard was writing. 'The types themselves,' suggest Pollard, 'may still be in existence, but unrecognized, and no longer in use'. With type he means, I think, to include punches and matrices. I have indicated briefly in the index whether the materials of a founder have been preserved, and where. The largest collection, which may yet yield surprise, is of course that of Stephenson, Blake and Co. It should also be remembered that, after the type-foundry of the Oxford University Press was re-started in 1853, many new matrices were bought. Some of these later types probably belong to the period of this *Handlist*. During the last twenty years substantial collections of typefounding materials, including punches from the Caslon and Figgins foundries, have been added to the St Bride Printing Library. Where sale catalogues have been published, they commonly include inventories that would otherwise be inaccessible or lost. It is particularly sad, therefore, that of seven such catalogues known to Reed, which I have listed in Appendix vi, only three can now be located. One of them, happily, has come to light in the last decade, and it must be hoped that others may also have survived, unnoticed, somewhere.

Each foundry is listed alphabetically by the surname of the proprietor (in preference to such abstractions as the Imperial,

Polyglot or British letter foundries). Minor variations in the style
of a firm are ignored, so that the chronological sequence of its
specimens may be followed easily. Thus, specimens of the Fry
foundry appear in the order: Joseph Fry and Co, Joseph Fry and
Sons, Edmund Fry and Co, Fry and Steele, and so on; but the
specimens issued by Isaac Moore acting as manager for Joseph Fry
are listed under Moore's own name. Where a firm's changes of
style are peculiarly confusing, as in the case of the two Caslon
foundries, the user may find it simpler to turn first to the index,
where summary histories and lists of specimens are given. In the
index, too, will be found some general bibliographical references
concerning individual firms: these are supplementary to the
references given in Johnson's edition of Reed's *History*. Literature
concerning a single specimen is cited in the main entry in the
Handlist.

The spelling and punctuation of each title page has been
reproduced, but not the use of capitals or different styles of type.
Matter omitted in transcription is indicated by three points of
suspension. Editorial interpolations are given in square brackets.
Titles on boards or wrappers are noted only where they supplement
a title page, or provide a substitute for it.

Where a conjectural date has been given, without explanation,
it has been taken from the most recent of the authorities cited.
Specimens are chronologically arranged by the printed date on the
title page, even where the evidence of a manuscript date or a price
list (or both, as in the Austin specimen of 1819, **3**) indicates a later
issue. Many of the accepted dates have been challenged, and
evidence for the revision is given. Occasionally, as in the case of
the Cottrell octavo specimens (**90**), any attempt to assign close
conjectural dates has been abandoned altogether, since such cases
need more detailed study than a handlist on this scale can provide
room for. The decision whether variations between copies should
be treated as variant states of one specimen, as in the case of **90**
and **107**, or as two or more different specimens, such as **9** and **10**,
has often had to be decided arbitrarily, and no doubt inconsistently.
It will be obvious that there is an element of artificiality about the
entities to which the numbers in the *Handlist* are assigned. A
related problem is raised, particularly in the period from 1790
to 1810, by single leaves, which often bear a printed date and were
no doubt separately distributed on occasion. Where such detached
leaves have been listed by previous compilers (for example, the
Fry specimens (**138** and **139**) I have kept this separate identity, even
where the only copies located are now an integral part of another
specimen book.

I have indicated the format of each specimen very approximately
indeed by the simple use of the conventional terms 8⁰ (octavo),
4⁰ (quarto), 2⁰ (folio) and 1⁰ (broadside). Each printed leaf is

recorded, including price lists; blank leaves, printed wrappers and boards are not counted. Folding leaves are treated as one leaf, but they are sometimes bound as two, which may suggest spurious variation between copies. In the case of a single copy known, or where nearly all known copies agree in their contents, the collation is given after the format statement. Otherwise it is noted separately, copy by copy, with a brief indication of manuscript notes, price lists, or dated leaves that may indicate a date later than that of the title page or wrapper.

The known locations of each specimen have been cited, using an idiosyncratic series of abbreviations borrowed from Mr J. S. G. Simmons. However, I have not multiplied locations for the commoner printed books, such as handbooks and encyclopaedias, which incorporate specimens: in such cases only the St Bride and British Library locations are reported. A specimen in a private collection is noted only if it is the sole copy known, or one of two. It might have been expected that large union cataloguing projects would bring unknown material to light, but in fact the National Union Catalog has failed to reveal a single specimen that was not already known, although it does indeed provide further locations for some of them. It may be hoped and expected that the making of the Eighteenth-century Short Title Catalogue, with its generous inclusion of broadside and pamphlet material, will uncover unrecorded specimens. For this *Handlist*, I have given locations only for copies that I have been able to see and examine in detail, or of which I have had a trustworthy report. For these, I am deeply indebted to the many librarians who have been unfailingly generous in providing information and responding to tiresome minute queries.

My thanks go in the first place, therefore, to Mrs Virginia Adams of the Providence Public Library, Providence, Rhode Island; Dr H. Buck, who gave assistance at the Staats- und Universitätsbibliothek, Frankfurt am Main; Mr John Buechler of the University Library at Burlington, Vermont; the late Netty Hoeflake of the Stichting Museum Enschedé, Haarlem, and her successor, Dr Gonne Flipse; Dr Sten G. Lindberg, Kungliga Biblioteket, Stockholm; Mr Kenneth A. Lohf, Columbia University Library; Mr David McKitterick, University Library, Cambridge; Mr Marcus McCorison, American Antiquarian Society, Worcester, Massachusetts; Mr Paul Morgan, Bodleian Library, Oxford; Mr John Morris, National Library of Scotland; Madame Jeanne Veyrin-Forrer, Bibliothèque Nationale, Paris; Mr James Wells and Mr Rick Johnson, Newberry Library, Chicago.

I owe many thanks to Mr James Blake and Mr Roy Millington for their hospitality and assistance at Stephenson, Blake & Co Ltd, Sheffield; and to Mr Nicolas Barker, Mr Roy Caslon, Dr Philip Gaskell and Dr Berthold Wolpe, owners of uncommon specimens

who have generously placed them at my disposal.

A handlist of this kind is happily never complete. I am grateful to Mr Martin Orskey, who provided its latest, previously un-recorded, addition, the specimen sheet of Simon Stephenson, 1790 (**187**); and also to Mr Ben Weinreb, who made it possible for Reed's own copy of the only known copy of the sale catalogue of Henry Bower's foundry, 1851, to join the rest of the Reed collection in the St Bride Printing Library.

To these names, I must add those of Rollo Silver and Terry Belanger, to whose generous support I (in common with many others) owe many opportunities to work in libraries in the United States. Dr Belanger was particularly effective in disentangling the complexities of the material of the American Type Founders' Library at Columbia University.

Users of this *Handlist* may notice that it is printed from type. For this departure from the rule established for the series in which it appears, and for much indulgence besides, I thank the Oxford Bibliographical Society, and acknowledge the co-operation of my colleagues in the Department of Typography & Graphic Commun-ication in the University of Reading.

A final acknowledgement is due to the two editors of the Society who were responsible for initiating work on this *Handlist*, Mr J. S. G. Simmons and the late Harry Carter. It is to the memory of Harry Carter that I would dedicate this pamphlet, less for what it is than for the further work on the history of printing types that it may, I hope, make easier.

I should of course welcome any corrections or additions.

James Mosley
St Bride Printing Library
London EC4Y 8EE

September 1982

[1] H. D. L. Vervliet, Introduction, p. 7, to *The type specimen of the Vatican Press, 1628: a facsimile* (Amsterdam, 1967). In a note, the definition is extended to include 'type specimens that advertise the development or availability for use of some *one* particular type'.

[2] Bound with a copy of the Oxford specimen of 1768 (with its supplements of 1770 and 1775) in the Library of King's College, London. The recipient was a Dr Glasse.

[3] *Fournier on typefounding: the text of the Manuel typographique (1764–1766) translated into English and edited with notes by Harry Carter* (London, 1930). A reprint with a new foreword was published by Burt Franklin, New York, in 1973.

[4] *Mechanick exercises on the whole art of printing (1683–4), by Joseph Moxon; edited by Herbert Davis and Harry Carter.* (London, 1958).

[5] Harry Carter (and others), 'A list of type specimens', *The Library*, 4th ser., 22 (1941–2), pp. 186–204.

[6] *Type specimen facsimiles: reproductions of fifteen type specimen sheets issued between the sixteenth and eighteenth centuries, accompanied by notes mainly derived from the researches of A. F. Johnson, Harry Carter, Matthew Carter, Netty Hoeflake, Mike Parker; general editor, John Dreyfus* (London, 1963).

[7] Haebler was loyally defended by Victor Scholderer (*The Library*, 4th ser., 11 (1930–1), pp. 116–20); but his 'axiom that until 1501 the type of every press was unique ... is a methodological fiction becoming more fictitious as time goes on' (Harry Carter, *A view of early typography up to about 1600* (Oxford, 1969), p. 104).

[8] *Typefoundries in the Netherlands from the fifteenth to the nineteenth century, by Charles Enschedé: an English translation with revisions and notes by Harry Carter, with the assistance of Netty Hoeflake; edited by Lotte Hellinga* (Haarlem, 1978).

[9] A reprint, to be published by Garland Publishing, Inc., New York, is in preparation.

[10] William Blades, *Some early type specimen books of England, Holland, France, Italy, and Germany* (London, 1875).

[11] Type specimen books in the Caxton Exhibition 1877, enlarged and corrected by Talbot B. Reed (St Bride Printing Library, acc. no. 5772).

[12] The beginning of the process may be seen in Charles Whittingham's accounts for the printing of specimens for William Caslon III's Salisbury Square foundry, a reference I owe to Mr Iain Bain. Setting and supplying six proofs of individual pages is charged separately, item by item, from 2 April to 28 May 1794, and the printing of 250 copies of 'a Specimen of Printing Types, 35 pages' is charged in December at £22. 9s. (British Library, Add. MS. 41, 902, f.41). This is presumably the book dated 1795. Two-page sheets were set, printed, and individually charged in quantities as great as 575 copies, while a 'Title and Dedication to Specimen' was printed in only 500 copies (ff. 41ᵛ, 42). The extra leaves may have been distributed separately or added to copies of the 1795 specimen.

[13] A thorough revision of Berry and Johnson's work, governed by the conventions that they adopted, is hardly possible or even desirable. A natural division suggests itself at the end of the century. It would be possible to draw up a fairly complete *Typenrepertorium*, accompanied by facsimiles from type specimens, to the end of the eighteenth century. Something very much less comprehensive in the way of a catalogue might also be attempted for the remaining period before the common use of mechanical composition brought a new uniformity to book production. But for the first of these projects, it should be noted that the *Catalogue*, despite its detail, leaves essential information unrecorded. It is not enough to list all body types under a blanket heading such as 'D. Pica to Non-pareil'. It should be possible to document the appearance of each type by each major founder. A more detailed list of the eighteenth-century material of the Caslon foundry at Chiswell Street, incorporating such information will be found accompanying a facsimile of the Caslon specimen book of 1766 in *Journal of the Printing Historical Society*, 16 (1981–2).

[14] For example, **P17**, **P33** and **P43**.

[15] *Nicholas Nicholls* [Specimen of Hebrew and Anglo-Saxon types, 1656.] Single sheet 17.6 × 28 cm. (Berry & Johnson, p. 2).

This entry by Berry and Johnson ostensibly describes a specimen sheet, attributable to Nicholls, of the Hebrew and Anglo-Saxon types that he cast for the University of Oxford. The authors locate it in the University Archives, but do not cite a reference. No single item answering exactly to their description can now be found there, but there is a specimen of Hebrew type only, measuring 20.5 × 15 cm, in a folder bearing the press mark S.E.P./P/17b/4. With it are several related items including three small fragments which are rough pulls of setting of Anglo-Saxon type. The specimen of Hebrew type is reproduced and discussed in Morison, *John Fell*, at p. 236. In most particulars, except for size and the lack of an Anglo-Saxon type, it corresponds to the description given by Berry and Johnson: the text is the opening of the Epistle of Jude; a border of flowers surrounds the text; and at the foot is the signature, struck through, of Gerard Langbaine, the Keeper of the University Archives. It is believed that this is a sheet that Langbaine sent to Nicholls in 1652 to guide him in making supplementary sorts to the fount of Hebrew for which the University had bought matrices at Leyden in 1637. The border is not found in Oxford printing and it is thought that the specimen probably came from Holland about the same time as the matrices. These were from the stock of a deceased typefounder at Leyden, Arent Corneliszoon van Hoogenacker, under whose name the specimen is listed in W. Hellinga, *Copy and print in the Netherlands* (Amsterdam, 1962), p. 124. The other fragments show a Pica Anglo-Saxon type which appears to be the one supplied by Nicholls to the University in 1656 for use in Somner's *Dictionarium Saxonico-Latino-Anglicum* (1659). They are not formal type specimens.

References

Berry & Johnson
W. T. Berry and A. F. Johnson, *Catalogue of specimens of printing types by English and Scottish printers and founders 1665–1830* (London, 1935).

Bigmore & Wyman
E. C. Bigmore and C. W. H. Wyman, *A bibliography of printing* (London, 1880–86).

Birrell & Garnett
Birrell & Garnett Ltd, *Catalogue of typefounders' specimens, books printed in founts of historic importance, works on typefounding, printing and bibliography; offered for sale* (London, 1928). Compiled by Graham Pollard.

Caxton Celebration Catalogue
Catalogue of the loan exhibition of antiquities, curiosities and appliances connected with the art of printing; Caxton Celebration 1877, edited by George Bullen (London, 1877).

Gaskell
Philip Gaskell, *A bibliography of John Baskerville* (Cambridge, 1959; reprinted with additions and corrections, Chicheley, 1973).

Gray
Nicolete Gray, *Nineteenth-century ornamented typefaces* (London, 1976). Revised edition of *Nineteenth-century ornamented types and title-pages* (1938).

Hansard
T. C. Hansard, *Typographia* (London, 1825).

Hart
Horace Hart, *Notes on a century of typography at the University Press, Oxford* (Oxford, 1900; reprinted with an introduction and additional notes by Harry Carter, 1970).

Maxted
Ian Maxted, *The London book trades 1775–1800: a preliminary checklist of members* (Folkestone, 1977).

Mores
Edward Rowe Mores, *A dissertation upon English typographical founders and founderies, 1778*, edited by Harry Carter and Christopher Ricks. Oxford Bibliographical Society, Publications, new series, ix (Oxford, 1961).

Reed
Talbot Baines Reed, *A history of the old English letter foundries* (London, 1887).

Reed-Johnson
Talbot Baines Reed, *A history of the old English letter foundries*, revised and enlarged by A. F. Johnson (London, 1952).

Simmons
J. S. G. Simmons, 'Specimens of printing types before 1850 in the typographical library at the University Press, Oxford', *The Book Collector*, vol. viii (1959), pp. 397–410.

Supp.
W. T. Berry and A. F. Johnson, 'A note on the literature of British type specimens, with a supplement to the Catalogue', *Signature*, new series, no. 16 (1952), pp. 29–40.

Todd
William B. Todd, *A directory of printers and others in allied trades, London and vicinity* (London, 1972).

Locations

Abbreviations

All Souls	All Souls College, Oxford
Amer.Ant.Soc.	American Antiquarian Society, Worcester, Massachusetts
Ant.Soc	Society of Antiquaries, London
Barrow PL	Barrow-in-Furness Public Library, Cumbria
B'ham.RL	Reference Library, Birmingham
BL	Reference Division, British Library, London
BN	Bibliothèque nationale, Paris
Bodl.	Bodleian Library, Oxford
Ch.Ch	Christ Church, Oxford
Col.UL	Columbia University Library, New York
CUL	University Library, Cambridge
Enschedé	Stichting 'Museum Enschedé', Joh. Enschedé en Zonen, Haarlem
Fitzwilliam	Fitzwilliam Museum, Cambridge
Frankfurt	Stadt- und Universitätsbibliothek, Frankfurt am Main
Grolier	Grolier Club, New York
Harvard	Houghton Library, Harvard University, Cambridge, Massachusetts
Hereford CL	County Library, Hereford
Huntington	Huntington Library, San Marino, California
Leipzig	Deutsche Bücherei, Leipzig
Magd.Coll.Camb	Magdelene College, Cambridge
McGill	McGill University Library, Toronto
Newberry	Wing Collection, Newberry Library, Chicago
NL Ireland	National Library of Ireland, Dublin
NLS	National Library of Scotland, Edinburgh
NYPL	New York Public Library
OUP	University Press, Oxford
PRO	Public Record Office, London
Prov.PL	Public Library, Providence, Rhode Island

Rylands	John Rylands University Library, Manchester
S.Bl	Stephenson, Blake & Co Ltd, Sheffield
SFPL	San Francisco Public Library
Soane	Sir John Soane's Museum, London
Sohm	Sohmian Collection, Kungliga Biblioteket, Stockholm
Stat.Co	Stationers' Company, London
StB	St Bride Printing Library, London
Trin.Coll.Camb	Trinity College, Cambridge
V&A	Victoria and Albert Museum, London
Vt.UL	University Library, University of Vermont, Burlington, Vermont
Yale	Beinecke Library, Yale University, New Haven, Connecticut

Typefounders' specimens

1 George Anderton 1753
[Specimen of Great Primer roman and italic.
Birmingham, 1753.]

Mores, p. 80.
Location: not known.

2 Augustus Applegath 1826
A catalogue of the printing types and
materials, with specimens of the letter of an
extensive printing office, including a
stereotype and letter foundry ... Duke
Street, Stamford Street, Blackfriars. [Sale
catalogue, Saunders and Hodgson, 26–8 June
1826.]

8⁰. 32 p., 30 leaves.
Location: BL (Sale catalogues, Hodgson).

30 leaves of type specimens, some headed
'Applegath'. The name of the owner of the
materials is not given, but it is likely that it
was Augustus Applegath, who was forced to
sell his Duke Street premises and stock during
the trade depression of 1826. See W. T. Berry,
'Augustus Applegath', *Journal of the Printing
Historical Society*, no. 2 (1966), p. 53.

3 Richard Austin 1819
Specimen of printing types, cast at Austin's
Imperial Letter-foundery, Worship-Street,
Shoreditch, London. 1819.

8⁰. Berry & Johnson, p. 75.
Location: Enschedé (6 leaves); S.Bl (12 leaves;
price list dated June 1820); StB (24 leaves;
price list dated 24 June 1827; date cut from
title page and '1827' added in MS.); Vt.UL
(24 leaves; price list dated 24 June 1827;
date on title page cancelled in MS.).

4 John Baine 175–?
[Specimen of printing types.]

Mores, p. 80; Reed, p. 349.

Location: not known. Reed suggests a date of
'1756?'.

5 John Baine and Grandson in Co. 1787
A specimen of printing types by John Baine
and Grandson in Co. letter-founders
Edinburgh MDCCLXXXVII.

8⁰. 20 leaves. Berry & Johnson, p. 57; Supp.
p. 35.
Location: Amer.Ant.Soc.

6 John Baskerville 1754
A specimen by John Baskerville of
Birmingham, in the county of Warwick, letter-
founder and printer. [At the foot:] MDCCLIV.

1⁰. Berry & Johnson, p. 29; Gaskell ii.
Facsimiles: Monotype recorder, vol. 26 (Sep–Oct
1927), p. 9; Reed-Johnson, fig. 75 (both
facsimiles omit the first word of the title).
Location: B'ham.RL (2 copies, undated);
Col.UL; Frankfurt; Prov.PL (undated); StB.

7 John Baskerville [1757]
A specimen by John Baskerville of
Birmingham.

1⁰. Berry & Johnson, p. 29; Gaskell v;
Simmons 2.
Facsimile: Berry & Johnson, pl. 3.
Location: Col.UL (2 copies); CUL; Fitz-
william; Harvard; OUP (2 copies); Rylands;
Yale (2 copies).

8 John Baskerville c. 1760
A specimen by John Baskerville of
Birmingham letter-founder and printer.

1⁰. Berry & Johnson, p. 30; Supp. p. 35;
Gaskell ix.
Facsimiles: D. B. Updike, *Printing types* (1922),
fig. 270 (reduced).

Location: B'ham.RL; BN (2 copies); Cercle de la Librairie, Paris; Enschedé; Prov.PL; Yale.

9 John Baskerville from c. 1762, 1st ed.
A specimen by John Baskerville of Birmingham.

1º. Berry & Johnson, p. 30; Supp. p. 35; Gaskell x.
Facsimile: Gaskell, pl. 5 (reduced).
Location: B'ham.RL; BN; University Printing House, Cambridge.

10 John Baskerville from c. 1762, 2nd ed.
A specimen by John Baskerville of Birmingham.

1º. Berry & Johnson, p. 30; Supp. p. 35; Gaskell xi.
Location: Amer.Ant.Soc. (intermediate state); B'ham.RL (2nd state); BN (2 copies, 1st and 2nd states); CUL (1st state); Newberry (2nd state).

11 John Baskerville 1775
A specimen of Baskerville's types. Birmingham, 1775.

2º. 2 leaves. Berry & Johnson, p. 30; Supp. p. 35; Gaskell xvi.
Location: BN (leaf 1 only); CUL.

12 Sarah Baskerville 1777
A specimen of Baskerville's types. Birmingham, 1777.

2º. 2 leaves. Berry & Johnson, p. 31; Supp. p. 35; Gaskell xvi.
Facsimile: Gaskell.
Location: Enschedé.

13 John Bell 1788
John Bell, of the British Library, Strand, London, being engaged in the establishment of a new printing letter foundry, he begs leave to present the public with a specimen of the first set of types which have been completed under his directions by William Coleman, regulator, and Richard Austin, punch-cutter. Printers may be supplied at present with types agreeable to this specimen, and afterwards with every other sort which shall be completed by J. Bell, however superior they may be, on terms usually observed by other founders. May, 1788.

8º. 3 leaves. Berry & Johnson, p. 58.
Location: BN.

14 John Bell c. 1789
Specimen of Bell's new printing types, which have been completed under his directions, at the British Letter Foundry, by William Colman, regulator, and Richard Austin, punch-cutter. Printers in general may be now furnished with these original types, at the prices usually charged for common types, by applying to the founder, J. Bell, British-Library, Strand, London.

8º. 7 leaves. Berry & Johnson, p. 59.
Location: BN; Soane.

15 Bell and Stephenson 1789
A specimen of printing types cast at Bell & Stephenson's original British Letter Foundry, from punches and matrices executed under their direction. By William Colman, regulator, and Richard Austin, punch-cutter. In the Savoy, London. 1789.

8º. 9 leaves. Berry & Johnson, p. 59.
Facsimile: S. Morison, *John Bell* (1930), pp. 139–57.
Location: Bodl.

16 Anthony Bessemer 1821
Specimen of the last modern cut printing types, by A. Bessemer, letter-founder, Hitchin, Herts. 1821.

8º. 13 leaves. Berry & Johnson, p. 81.
Location: StB.

17 Anthony Bessemer and John James Catherwood 1822
Specimen of the last modern cut printing types, by A. Bessemer & J. J. Catherwood* letter-founders, Hitchin, Herts.
*J. J. Catherwood, late of the Chiswell

Street letter-foundry, London. 1822.
Maurice, printer, Fenchurch Street.

8⁰. 17 leaves.
Location: Vt.UL.

18 Anthony Bessemer and John James Catherwood 1825
Specimen of the last modern cut printing types, by A. Bessemer & J. J. Catherwood* letter-founders, Hitchin, Herts.
*J. J. Catherwood, late of the Chiswell Street letter-foundry, London. 1825.

8⁰. Berry & Johnson, p. 82.
Location: S.Bl (25 leaves); StB (24 leaves); Vt.UL (25 leaves).

19 Anthony Bessemer 1830
Specimen of the last modern cut printing types, by A. Bessemer, letter-founder, 54, Red Lion Street, Clerkenwell, London. MDCCCXXX.

8⁰. Berry & Johnson, p. 83.
Facsimile: *Journal of the Printing Historical Society*, no. 5 (1969).
Location: StB (25 leaves); Vt.UL (25 leaves).

20 Blake, Garnett and Co. c. 1819
A specimen of printing types, &c. by Blake, Garnett, & Co. (successors to Mr. W. Caslon, of London) letter-founders, Sheffield.

8⁰. Berry & Johnson, p. 77.
Location: S.Bl (124 leaves; price list dated April 1819); StB (78 leaves, i.e. 76 plus stubs of 2 missing leaves); Vt.UL (103 leaves).

21 Blake, Garnett and Co. 1821
[On wrapper:] Supplement to Blake, Garnett, and Co.'s specimen. 1821.

8⁰. 21 leaves.
Location: Vt.UL (the last figure of the date altered to 4 in MS.).

22 Blake, Garnett and Co. 1826
[On wrapper:] Supplement to Blake, Garnett, & Co's specimen. 1826.

8⁰. 19 leaves. Berry & Johnson, p. 78.

Location: StB (the last figure of the date supplied in MS.).

23 Blake, Garnett and Co. 1827
[On wrapper:] Supplement to Blake, Garnett, & Co's specimen. 1827.

8⁰. 6 leaves. Berry & Johnson, p. 79.
Location: StB (the last figure of the date supplied in MS.).

24 Blake, Garnett and Co. 1827
Specimen of printing types, by Blake, Garnett, & Co. (successors to Mr W. Caslon, of London,) letter-founders, Sheffield.

8⁰. Berry & Johnson, p. 78; Simmons 3.
Location: Harvard (118 leaves; '1827' in MS. on wrapper); OUP (120 leaves; dated '[1820]' by Berry & Johnson, but Simmons points out its similarity to the StB copy); StB (118 leaves; dated 1827 on front board; price list of 16 Feb 1825).

25 Blake, Garnett and Co. 1827
A select specimen of book and newspaper types, by Blake, Garnett, & Co. 1827.

8⁰. 19 leaves.
Location: Vt.UL (price list of Nov 1823).

26 Blake, Garnett and Co. 1828
[On wrapper:] Supplement to Blake, Garnett, & Co's specimen. 1828.

8⁰. 7 leaves. Berry & Johnson, p. 79.
Location: StB (the last figure of the date supplied in MS.).

27 Blake, Garnett and Co. 1830
[On wrapper:] Supplement to Blake, Garnett, & Co's specimen. 1830.

8⁰. 8 leaves.
Location: Vt.UL (the last figure of the date supplied in MS.; price list of 1825).

28 Blake, Garnett and Co. c. 1830
Specimen of printing types, by Blake, Garnett, & Co. (successor to Mr. W. Caslon, of London,) letter-founders, Sheffield.

8⁰. Berry & Johnson, p. 79; Birrell & Garnett
94a.

The location of the Birrell & Garnett copy
(160 leaves, some dated 1826, 1827 and 1830)
is not known. Vt.UL has one of 145 leaves,
some dated later than 1830; dated 1826 on the
front board, but with last figure altered in MS.
to 9; price list dated 16 Feb 1825.

29 Blake and Stephenson 1830
[On wrapper:] Select specimen of printing
types, by Blake and Stephenson, Sheffield.
1830.

8⁰. 72 leaves. Berry & Johnson, p. 80.
Location: StB.

30 Bower, Bacon and Bower 1810
1810. A specimen of improved printing types,
cast by Bower, Bacon & Bower, printers and
letter founders, Sheffield.

8⁰. 29 leaves. Berry & Johnson, p. 72.
Location: S.Bl.

31 Bower, Bacon and Bower 1813
[On wrapper:] 1813. A specimen of improved
printing types, cast by Bower, Bacon, and
Bower, letter founders, Sheffield.

8⁰. 57 leaves.
Location: Vt.UL.

32 Bower, Bacon and Bower 1826
[On front board:] Bower, Bacon & Bower's
specimen of printing types, Sheffield. [Rear
board and spine dated:] 1826.

8⁰. Berry & Johnson, p. 72 (their date is
'c. 1825').
Location: Col.UL (109 leaves); CUL (114
leaves); S.Bl (113 leaves; price list of 1 Feb
1825).

The copy recorded by Berry & Johnson, in
the possession of R. G. Blake, comprised 125
leaves.

33 Bower and Bacon 1830
Bower & Bacon's, improved specimen of
printing types, Sheffield. 1830.

8⁰. 146 leaves (i.e. 145 plus the stub of
1 missing leaf). Berry & Johnson, p. 72.
Location: StB.

34 William Caslon c. 1730
[Specimen of printing types.]

1⁰. Supp. p. 31.
Location: BL.

35 William Caslon before 1734
[Two fragments showing non-Latin types.]

Location: BL (463. h. 11., nos. 69 and 145).
Apparently from an early state of **36**. See
J. Mosley, 'The early career of William
Caslon', *Journal of the Printing Historical
Society*, no. 3 (1967), pp. 76–7.

36 William Caslon 1734
A specimen by W. Caslon, letter-founder,
in Ironmonger-Row, Old-Street, London.
[At the foot of the last column:] 1734.

1⁰. Berry & Johnson, p. 13.
Facsimiles: *Journal of the Printing Historical
Society*, no. 3 (1967), facing p. 66; D. B.
Updike, *Printing types* (1922), fig. 262
(reduced).
Location: BL (imperfect, lacking the flowers);
Col.UL.

37 William Caslon '1734' (actually 1738–52)
A specimen by William Caslon, letter-
founder, in Chiswell-Street, London. [At the
foot of the last column:] 1734.

1⁰. Berry & Johnson, p. 13; J. Mosley, 'The
early career of William Caslon', *Journal of
the Printing Historical Society*, no. 3 (1967),
pp. 77–9.
Facsimile: J. F. McRae, *Two centuries of type-
founding* (1920).
Location: BL; StB; etc.
In E. Chambers, *Cyclopaedia*, 2nd ed. (London,
1738), vol. 2, s.v. 'Letter'. This specimen was
incorporated in each subsequent edition until
the 7th of 1752–3. Nine minor variant states
have been distinguished.

38 William Caslon c. 1740
A specimen by William Caslon, letter-founder in Chiswell-Street, London. [At the foot:] Dublin: printed by R. Reilly, on Cork-Hill.

1°. Berry & Johnson, p. 14; Supp. p. 32.
Location: Caslon; Harvard.
In E. Chambers, *Cyclopaedia*, 3rd ed. (Dublin, 1740).

39 William Caslon 1742
A specimen by W. Caslon, letter-founder, in Chiswel-Street, London. 1742.

1°. Berry & Johnson, p. 15.
Facsimile: Berry & Johnson, pl. 1.
Location: BN; Bodl.; Enschedé; Frankfurt; Harvard; OUP.

40 William Caslon c. 1742
A specimen by William Caslon, letter-founder, in Chiswel-Street, London. [At the foot:] Dublin: printed by A. Reilly, on Cork-Hill.

1°. Berry & Johnson, p. 14; Supp. p. 14.
Location: Bodl.; Caslon.
In E. Chambers, *Cyclopaedia*, 5th ed. (Dublin, 1742).

41 William Caslon and Son 1746
A specimen by W. Caslon and Son, letter-founders, in Chiswel-Street, London. 1746.

1°. Harry Carter (and others), 'A list of type specimens', *The Library*, 4th series, vol. 22 (1942), p. 200.
Location: Frankfurt.

42 William Caslon and Son 1748
A specimen by W. Caslon and Son, letter-founders, in Chiswel-Street, London. 1748.

1°. Berry & Johnson, p. 16.
Location: Bodl.; Caslon; Col.UL; Frankfurt.
Contents: black letter, Anglo-Saxon and non-Latin types only.

43 William Caslon and Son 1749
A specimen by W. Caslon and Son, letter-founders, in Chiswel-Street, London, 1749.

1°. Berry & Johnson, p. 16.
Location: Frankfurt; Sohm.
Contents: roman and italic types only.

44 William Caslon and Son before 1752
[Specimen of flowers, titling letter, etc.]

1°. Reed-Johnson, p. 238.
Location: not known.

A contemporary source quoted by Reed remarks that William Caslon and Son 'have lately printed three Broad Sheet specimens of their curious Types; one of them consisting of all the common Sorts of Letter used in printing; the second Sheet is divers sorts of Orientals, Old English, and Saxon; and the third contains a great Variety of curious Flowers and Fancies for ornamenting of Title-Pages, Tickets, &c. also several sorts of Titling-Letter of Roman, Old English and Greek' (*An essay on the original, use, and excellency of the noble art and mystery of printing* (London, 1752), p. 8). The first two of these broadsheet specimens can probably be identified with **43** and **42**, above. The third, listed here as **44**, has not been found.

45 William Caslon and Son 1763
A specimen of printing types, by William Caslon, and Son, letter founders, in London. London: printed by Dryden Leach.
M DCC LXIII.

4°. [A]⁴, B-I⁴, *I⁴, K-M⁴, [1 blank leaf], []⁴, []². Laid paper. Berry & Johnson, p. 17; Supp. p. 32.
Location: Amer.Ant.Soc.
This unique specimen appears to consist of two distinct but complementary items bound together. The first 8 sections, sheets [A] to H, show only types, in a setting that, apart from the title page, is repeated in specimens **46** to **50**, below. Sheets I to M are from the undated specimen of flowers, c. 1774–8 (**51**, below). Its unsigned preliminary 4-leaf section, including the title leaf, follows the blank leaf in the collation above.

46 William Caslon and Son 1764

A specimen of printing types, by W. Caslon and Son, letter founders, in London. London, printed by Dryden Leach, MDCCLXIV.

4⁰. [A]⁴, B–H⁴. 32 leaves. Laid paper. Berry & Johnson, p. 18; Supp. p. 32.
Location: Barker; B'ham.RL (36 leaves; includes 4 leaves of flowers, signed I); BL; CUL; OUP; Wolpe.

47 William Caslon and Son 1764

A specimen of printing types, by W. Caslon and Son, letter-founders, in London. London, printed by Dryden Leach, MDCCLXIV.

4⁰. [A]², B–S². 36 leaves. Wove paper. Berry & Johnson, p. 18; Supp. p. 32.
Location: BL; BN (Rés. p. Q. 231 (1) and (2); a made-up copy including parts of **46** and **51** (cf. **45**, above); 55 leaves); Harvard (38 leaves; 2 unsigned leaves at end); King's College, London; Sohm; Wolpe (38 leaves; 2 unsigned leaves at end).

48 William Caslon and Son 1764

A specimen of printing types, by W. Caslon and Son, letter founders, London. Printed by John Towers, MDCCLXIV.

4⁰. [A]², B–S², []². 38 leaves. Wove paper. Berry & Johnson, p. 17.
Location: BL (2 copies); Bodl.; CUL; Harvard (2 copies); Newberry; StB; Trin.Coll.Camb.

49 William Caslon II 1766

A specimen of printing types, by William Caslon, letter founder, London. Printed by John Towers, MDCCLXVI.

4⁰. [A]², B–S², []². 38 leaves. Wove paper. Berry & Johnson, p. 18.
Location: All Souls; Amer.Ant.Soc; BL; Col.UL; King's College, London (2 copies); Newberry; NYPL (signed [A]-T²); StB; Vt.UL (32 leaves).

50 William Caslon II 1770

A specimen of printing types, by William Caslon, letter founder, London.

8⁰. 18 leaves. Berry & Johnson, p. 18.
Location: BL; StB; etc.

In P. Luckombe, *Concise history of . . . printing* (London, 1770; reissued as *The history and art of printing*, 1771), pp. 133–68. Facsimile reprint, 1966.

51 William Caslon II and Son c. 1774–8

A specimen of printing types, by W. Caslon and Son, letter-founders, in London. Printed by T. Wright, in Essex-Street, Strand.

8⁰. []⁴, I⁴, *I⁴, K–M⁴. 24 leaves. Laid paper. Berry & Johnson, p. 20; Supp. p. 32; Simmons 14.
Location: All Souls; Amer.Ant.Soc; Barker; BL; BN (Rés. p. Q. 231 (2); 23 leaves; lacks title); Col. UL (22 leaves); OUP; StB; Wolpe. The specimen poses two problems: it is undated; and it is complete, having no signed section before I and, despite the title, containing only flowers.

Berry & Johnson first suggested a date of 'c. 1785', assuming the firm of the title to be that of William Caslon III and his son. They subsequently decided that it was William Caslon I (d. 1766) and his son (Supp. p. 32). Neither suggestion is consistent with the address of the printer given on the title page. Westminster Rate Books show that T. Wright occupied premises in Essex Street only during the years 1772–8. During that period, the London directories for 1774–8 show that the Caslon foundry traded as William Caslon and Son, a partnership between William Caslon II (d. 1778) and his son.

A date between 1766 and 1785 is supported equally well by the contents. This book shows 32 more flowers than the specimen of 1766, which was reprinted without alteration in 1770 (**50**, above). The specimen book of 1785 (**55**, below), in its turn, adds a further 29 flowers to those shown here. A number of small details in the setting point to a similar inter- mediate position between **50** and **55**. The signatures were presumably planned in

order to complete the specimens printed by Leach on a very similar laid paper, **45** and **46**, above.

52 **William Caslon II and Son c. 1774–8**
Thirteen lines Pica. [At the foot:] Eleven, nine and seven lines Pica, with the lower case are nearly finish'd by W. Caslon and Son. 1⁰.

Facsimile: B. Wolpe, 'Caslon architectural', *Alphabet*, ed. R. S. Hutchings (London, 1964).
Location: BL; CUL; Wolpe.

This undated sheet seems most likely to belong to the period of the partnership between William Caslon II and his son, like **51**, above, with which 2 of the 3 known copies of it are bound. The types described here as nearly finished appear in the specimen of 1780 (**53**, below).

53 **William Caslon III 1780**
A specimen of large letters, by William Caslon, London. 1780.

1⁰. 2 sheets. B. Wolpe, 'Caslon architectural', *Alphabet*, ed. R. S. Hutchings (London, 1964), p. 62.
Location: All Souls.

54 **William Caslon III 1784**
A specimen of cast-ornaments on a new plan by William Caslon. London, 1784.

8⁰. *Musaeum typographicum Sohmianum* (Stockholm, 1815), p. 20; Reed, p. 256; Berry & Johnson, p. 19.
Location: not known. The date is probably an error. Reed added confusion by transcribing the name as 'William Caslon and Son'. The entry appears in *Musaeum typographicum Sohmianum* as no. 89. There is now no specimen with this date among the Sohm books, but there is a copy of the specimen of 1786 (**58**, below), and this is inscribed with the figure 89.

55 **William Caslon III 1785**
A specimen of printing types, by William Caslon, letter-founder to His Majesty.

London: printed by Galabin and Baker, MDCCLXXXV.

8⁰. 67 leaves. Berry & Johnson, p. 19.
Location: Amer.Ant.Soc; BL (2 copies); CUL; Harvard; Newberry; SFPL (63 leaves); Stat.Co; StB (2 copies, 67 and 65 leaves); Yale (2 copies).

56 **William Caslon III 1785**
A specimen of large letters, by William Caslon, London, 1785.

1⁰. 2 sheets. Berry & Johnson, p. 20.
Facsimile: (sheet 1 only) B. Wolpe, 'Caslon architectural', *Alphabet*, ed. R. S. Hutchings (London, 1964).
Location: Amer.Ant.Soc; BL (2 copies); BN; Harvard; Stat.Co (sheet 1 only); Vt.UL (sheet 1 only).

57 **William Caslon III 1786**
A specimen of printing types, by William Caslon, letter-founder to His Majesty.

2⁰. 8 p. Berry & Johnson, p. 21.
Location: BL; StB; etc.
In E. Chambers, *Cyclopaedia . . . with supplement and modern improvements by Abraham Rees* (London, 1786), vol. 3. There are two minor variant issues.

58 **William Caslon III 1786**
A specimen of cast ornaments on a new plan by William Caslon, letter-founder to His Majesty. London: printed by J. W. Galabin. M.DCC.LXXXVI.

8⁰. Supp. p. 34.
Location: BL (17 leaves); BN (16 leaves); Grolier; Harvard (16 leaves); Sohm (17 leaves); Stat.Co (16 leaves); StB (15 leaves).

59 **Elizabeth Caslon 1796–9**
[Specimens of printing types.]
5 leaves.

Location: NYPL (bound with **55**).

[1] Eliz. Caslon's new Canon. (25 × 21 cm.)
[2] Elizabeth Caslon's two-line Small Pica full-face. (24.5 × 21 cm.)

[3] Eliz. Caslon's new Double Pica.
(24 × 21 cm.)
[4] Eliz. Caslon's new Double Pica. 1796.
(24 × 21 cm.)
[5] Eliz. Caslon's new Pica. 1799.
For Elizabeth Caslon's management of the
Chiswell Street foundry and the cutting of
these types by John Isaac Drury, see T. C.
Hansard, *Typographia* (London, 1825),
p. 352, and Reed-Johnson, p. 247.

60 Caslon and Catherwood 1800
Specimen of printing types, by Caslon &
Catherwood, letter-founders, London.
T. Bensley, Bolt Court, Fleet Street, London.
1800.

8º. 52 leaves. Berry & Johnson, p. 21.
Location: B'ham.RL.

This appears to be a reissue of **55** with a
cancel title leaf.

61 Caslon and Catherwood c. 1802–5
New broad-face Long Primer of Caslon and
Catherwood, Chiswell Street. [At the foot:]
New broad-face Minion. This Minion is made
in a similar manner. Printed by A. Wilson,
Wild Court, Lincoln's Inn Fields.

1º. Berry & Johnson, p. 23; Simmons 19.
Location: County Record Office, Maidstone,
Kent (Stanhope Papers); OUP.

Berry & Johnson suggested a date of c. 1820
for this sheet, but rate books show that
Wilson left Wild Court after 1805. Wilson's
concern with Stanhope's stereotype process,
which was the occasion for this specimen,
dated according to his own account from
1802. (H. Hart, 'Charles Earl Stanhope and
the Oxford University Press', Oxford Histor-
ical Society, *Collectanea*, vol. 3 (Oxford, 1896),
p. 392.).

62 Caslon and Catherwood 1805
Specimen of printing types, by Caslon &
Catherwood, letter-founders, Chiswell Street,
London. T. Bensley, printer, Bolt Court,
Fleet Street, London. 1805.

8º. Berry & Johnson, p. 22; Simmons 18.
Location: Harvard; Newberry (34 leaves);
OUP (34 leaves); Vt.UL (2 copies, 17 and
35 leaves).

63 Caslon and Catherwood after 1805
Specimen of printing types, by Caslon &
Catherwood, letter-founders, Chiswell Street,
London. T. Bensley, printer, Bolt Court,
Fleet Street, London. [Date erased.]
8º.

Location: Col.UL (64 leaves; 1 leaf water-
marked 1810); CUL (44 leaves); StB (53
leaves); Vt.UL (2 copies, 53 and 54 leaves).

64 Caslon and Catherwood 1808
Caslon & Catherwood's specimen of printing
types.

8º. 12 p. Berry & Johnson, p. 23.
Location: BL; StB; etc.
In C. Stower, *The printer's grammar* (London,
1808), pp. [551–62]. Facsimile reprint, 1965.

65 Caslon and Catherwood c. 1808
Specimen of printing types, by Caslon &
Catherwood, letter-founders, Chiswell Street,
London. T. Bensley, printer, Bolt Court,
Fleet Street, London.

8º. 70 leaves. Berry & Johnson, p. 22.
Location: not known.

The copy described by Berry & Johnson had
the date 1808 added in MS. to the title page.

66 Caslon and Catherwood 1815
Specimen of printing types, by Caslon &
Catherwood, letter-founders, Chiswell Street,
London. T. Bensley, printer, Bolt Court,
Fleet Street, London. [On wrapper:] New
specimen of printing types. 1815.

8º. 77 leaves.
Location: Vt.UL.

Date erased from title page: cf. **63**, above.

67 Caslon and Catherwood 1816
Specimen of printing types, by Caslon &
Catherwood, letter-founders, Chiswell Street,

London. T. Bensley, printer, Bolt Court, Fleet Street, London. [On wrapper:] New specimen of printing types. 1816.

8°. 78 leaves.
Location: Vt.UL.

Date erased from title page: cf. **63**, above.

68 Caslon and Catherwood 1819

Specimen of printing types by Caslon & Catherwood, letter-founders, Chiswell Street, London. Bensley & Sons, printers. 1819.

8°.
Location: not known.

Entered in the catalogue of the American Type Founders Company Library held at Columbia University, but it does not appear in the ATF shelf list, and there is no record of its receipt at Columbia.

69 Caslon and Catherwood 1821

Specimen of printing types by Caslon & Catherwood, letter-founders, Chiswell Street, London. Bensley & Sons, printers. [On front board:] 1821.

8°. Berry & Johnson, p. 23.
Location: StB (126 leaves); Vt.UL (116 leaves).

In both copies, 'Catherwood' is deleted from the title page and 'Henry' inserted before 'Caslon' in MS.

70 Caslon and Livermore 1822

Specimen of printing types by Caslon & Livermore, letter-founders, Chiswell Street, London. Bensley, printer. [On wrapper:] New specimen of printing types. 1822.

8°. 137 leaves.
Location: Barker.

71 Caslon and Livermore c. 1825

Specimen of printing types by Caslon & Livermore, letter-founders, Chiswell Street, London. Bensley, printer.

8°. Berry & Johnson, p. 24.
Location: Col.UL (2 copies, 141 and 158 leaves); StB (160 leaves).

72 Caslon and Livermore 1827

Specimen of printing types by Caslon & Livermore, letter-founders, Chiswell Street, London. Bensley, printer. [On front board:] 1827.

8°.
Location: Enschedé (169 leaves); Newberry (164 leaves; lacks date on board, but catalogue entry suggests '1827?'.).

73 Caslon and Livermore 1829

Specimen of printing types by Caslon & Livermore, letter-founders, Chiswell Street, London. Bensley, printer. [On front board:] New specimen of printing types. 1829.

8°. 174 leaves. Berry & Johnson, p. 24.
Location: B'ham.RL.

74 Caslon and Livermore 1830

Specimen of printing types by Caslon & Livermore, letter-founders, Chiswell Street, London. London. Bensley, printer. [On front board:] Caslon foundry. Specimen of printing types. 1830.

8°. Supp. p. 34.
Location: Col.UL (166 leaves; price lists of 1 Feb 1825 and 25 Jun 1835); StB (178 leaves; price list of 1 Feb 1825).

75 William Caslon III 1795

A specimen of printing types, cast at the Salisbury-Square letter-foundry, by Wm Caslon, letter-founder to the King. London: printed by C. Whittingham, Dean Street, Fetter Lane. 1795.

8°. 35 leaves.
Location: Harvard.

76 William Caslon III 1795

A specimen of cast ornaments, by Wm Caslon, letter-founder to the King. London: printed by C. Whittingham, Dean Street, Fetter Lane. 1795.

8°. 29 leaves. Berry & Johnson, p. 25.
Location: Amer.Ant.Soc; Col.UL (23 leaves); CUL; Harvard (2 copies); Prov.PL (20

leaves); S.Bl; StB (2 copies, 29 and 22 leaves);
Vt.UL.

Price list dated 1 Jan 1796.

77 William Caslon III 1796

A specimen of printing types, by Wm Caslon,
letter-founder to the King. London: printed
by C. Whittingham. 1796.

8º. Berry & Johnson, p. 25.
Location: Amer. Ant. Soc (66 leaves); CUL
(68 leaves); Harvard (2 copies, 66 and 68
leaves); Prov.PL (65 leaves); S.Bl (65 leaves);
StB (2 copies, 65 and 67 leaves); Vt.UL (68
leaves).

78 William Caslon III 1798

A specimen of printing types, by Wm Caslon,
letter-founder to the King. London: printed
by C. Whittingham. 1798.

8º. Berry & Johnson, p. 26.
Location: CUL (3 copies, 77, 75 and 74
leaves); Newberry (75 leaves); Prov.PL 77
leaves); Stat.Co (76 leaves); StB (76 leaves).

79 William Caslon III 1798

A specimen of cast ornaments, by Wm Caslon,
letter-founder to the King. London: printed
by C. Whittingham. 1798.

8º. Berry & Johnson, p. 26.
Location: CUL (3 copies, 31, 30 and 30
leaves); Newberry (26 leaves); Prov.PL (30
leaves); SFPL (28 leaves); Stat.Co (31 leaves);
StB (30 leaves).

80 William Caslon III 1800

A specimen of cast ornaments, by Wm Caslon,
letter-founder to the King. London: printed
by C. Whittingham. 1800.

8º. 30 leaves. Berry & Johnson, p. 26.
Location: Col.UL (includes 2 leaves from a
specimen of William Caslon IV, one of which
is watermarked 1809).

81 William Caslon III and Son 1803

Specimen of printing types, by W. Caslon and
Son, letter-founders to the King. London.

Printed by C. Whittingham, Dean Street,
Fetter Lane, 1803.

8º. Berry & Johnson, p. 27.
Location: Col.UL (80 leaves; price list of
1 Sep 1804; name on title page altered in MS.
to 'W. Caslon Junr. & Co'); SFPL (83 leaves).
Reed, pp. 326, 329, records a copy with the
name altered in MS. to 'W. Caslon, junr.'
and the date to '1807'.

82 William Caslon IV c. 1808

Sanspareil eight lines Pica.

1º. Berry & Johnson, p. 27.
Location: not known.

This entry and the one that follows were
transcribed by Berry & Johnson from the
*Catalogue of the books in the library of the Typo-
thetae of New York* (New York, 1896), p. 26.
Although described there as 'broadsides',
they may conceivably have been the single
leaves showing these types which appear in **84**,
below. The conjectural date of 'c. 1808' may
in any case be too early: sanspareil matrices
seem to have been new in 1810 (Reed-
Johnson, p. 321).

83 William Caslon IV c. 1808

Sanspareil fifteen lines Pica.

1º. Berry & Johnson, p. 27.
Location: not known.

84 William Caslon IV c. 1816

A specimen of printing types, &c. by William
Caslon, Junr. (late W. Caslon and Son)
letterfounder, Salisbury Square, London.

8º. Berry & Johnson, p. 27.
Location: Col.UL (83 leaves); S.Bl (58 leaves;
on the front board: 'Some of Wm. Caslon's
specimens others preparing 1816.', the last
figure added in MS.).

85 William Caslon IV 1819

Catalogue of a valuable and extensive stock
of printing types, with specimens
comprehending founts of various weights,
from 13 line Pica to Pearl, almost the whole of

which is new, of modern cut and manufactured by Mr. W. Caslon of Dorset Street, Salisbury Square. Catalogues may be had at the foundry, no. 107, Dorset-Street, Salisbury-Square. [Sale catalogue, Saunders, 9 and 10 February 1819.]

8⁰. 18 p., 15 leaves.
Location: BL (Sale catalogues, Hodgson).

15 leaves of type specimens.

86 Thomas Cottrell 176–?
A specimen by Thomas Cottrell, letter-founder, in Nevil's-Court, Fetter-Lane, London.

1⁰. Berry & Johnson, p. 33.
Location: Sohm.

'The surviving Cottrell specimens are all undated and difficult to arrange' (Reed-Johnson, p. 290). There are four broadsides in the Sohmian Collection, listed here as **86-9**. They form two pairs each with one sheet that shows the conventional range of types and flowers, and one with large poster letters. One of the pairs (**89, 90**) shows more types than the other, and is presumably later.

87 Thomas Cottrell 176–?
[Specimen of large letters.]
[At the foot:] Cast by T. Cottrell, letter-founder, in Nevil's-Court, Fetter-Lane.

1⁰. Berry & Johnson, p. 33.
Location: Sohm.

88 Thomas Cottrell 176–?
A specimen by Thomas Cottrell, letter-founder, in Nevil's-Court, Fetter-Lane, London.

1⁰. Berry & Johnson, p. 34.
Location: Sohm.
Adds English Cannon roman and italic, Engrossing, and some flowers to the types shown in **86**.

89 Thomas Cottrell 176–?
[Specimen of large letters.]
[At the foot:] Cast by Thomas Cottrell, in Nevill's-Court, Fetter-Lane, London.

1⁰. Berry & Johnson, p. 34.
Location: Sohm.
Adds 12-line Pica capitals to the types shown in **87**.

90 Thomas Cottrell [between 176– and 1785]
A specimen of printing types, by Tho. Cottrell, letter founder, in Nevil's-Court, Fetter-Lane, London.

8⁰. Berry & Johnson, p. 35; Simmons 23.
Location: Amer.Ant.Soc (2 copies, each of 34 leaves, one incorporating a printed circular by Cottrell dated 1774, the other bearing the date 1786 in MS. on the title page); Atkinson (36 leaves; the front board lettered and dated 1781); BN (30 leaves); CUL (34 leaves, plus an indenture blank set in Cottrell's Engrossing); Newberry (32 leaves); OUP (2 copies, each of 34 leaves, one in a binding similar to that of the Atkinson copy, dated 1781); S.Bl (21 leaves; T. B. Reed's copy); StB (28 leaves).

Although the wording of the title page remains the same, these undated specimen books show many variations and they were clearly issued over a period of many years. Various conjectural dates were suggested by Reed and by Berry & Johnson: c. 1760, c. 1764, c. 1765, c. 1766, c. 1768. It may be more useful to suggest an approximate order, based on an examination of the contents and the state of the settings:

1	StB	6	BN
2	OUP 1	7	Amer.Ant.Soc 1 '1774'
3	Newberry	8	S.Bl
4	CUL	9	Amer.Ant.Soc 2 '1786'
5	OUP 2 '1781'	10	Atkinson

Copies 1–4 show Cottrell's Engrossing type in the setting that appears in Luckombe, *Concise . . . history of printing* (1770), **91**, below. This type is set to a different measure in 5 and 7–10 (it is missing from 6). 1–4 may therefore possibly antedate the use of the type by Luckombe. Copies 6–10 show, in addition to the Burgeois roman, an italic which is absent from 1–5. Copies 9 and 10 show a lower case for 10- and 12-line Pica capitals.

They also show flowers that appear to be late in style, and which are not shown in copies 1–8.

91 Thomas Cottrell 1770
[Specimen of flowers and Engrossing and Doomsday type.]

8°. 6 p. Berry & Johnson, p. 36.
Location: BL; StB; etc.
In P. Luckombe, *Concise history of . . . printing* (London, 1770), pp. 169–74; reissued as *The history and art of printing* (1771). Facsimile reprint, 1966.

92 Vincent Figgins 1793
Specimen of printing types, by Vincent Figgins, letter-founder, Swan Yard, Holborn Bridge, London. Printed by T. Bensley.

8°. Caxton Celebration Catalogue no. 4383; Bigmore & Wyman, I, p. 218; Reed, pp. 337–8, 344; Berry & Johnson, pp. 61–2; Supp. p. 36.
Location: StB (16 leaves, including extraneous matter; advertisement dated May 1793; provenance: William Blades, John Nichols); Wolpe (2 leaves; provenance: Figgins foundry).

The list of the first Figgins type specimens in Reed, p. 337–8, includes three with the title transcribed above. Two were said to be in the possession of 'J.F.' (James Figgins), and they were described as 'No date. (1792.) 4to, 2 pp.' and 'No date. (1793.) 4to, 5 pp.'. The third copy belonging to 'W.B.' (William Blades) is said to be dated 1794.
Blades's specimen is now StB 20293. It contains 16 leaves bound in mid-19th century boards probably added to it by Blades himself. The contents are: leaf [1] title; [2] advertisement; [3] Two-line English roman; [4] Long-bodied English roman, no. 2, June 1793; [5] Pica roman, no. 2; [6–13] [non-Latin types, from a specimen of the Fry foundry]; [14] Pica roman, no. 2. open [i.e. leaded]; [15] Small Pica; [16] New Pica. Leaves 1, 2, 3 and 5 are printed on the same heavy cream wove paper and have matching

stab holes that suggest that they were previously bound together.
The other surviving specimen consists of two conjugate leaves corresponding exactly with leaves 1 and 3 of the Blades copy. It seems likely that this is the '2 pp.' specimen listed by Reed.
In his text Reed describes the '5 pp.' specimen of 1793 as consisting of 'title, address, and three specimens'. 'In the next year,' he continues, Figgins issued 'an enlarged specimen book with the same title and address as before but containing twelve sheets of specimens, four of which were dated 1794'. This can only refer to the Blades specimen, but it demonstrates complete mis-apprehension of the contents. Blades's copy has 14 leaves of specimens, not 12, and none of them is dated 1794. It is the description of the previous specimen – of '5 pp.' – that would apply best to Blades's, if the extraneous Fry material and the three leaves that follow it were left out of account. Blades himself recognized, in his annotated copy of Bigmore & Wyman (StB 20488), that his copy contained extra matter that had nothing to do with Figgins, and it is difficult to believe that he conveyed no hint of this to Reed.
In Reed's own list of type specimens, based on page proofs of the Caxton Celebration Catalogue with additions and corrections in his own hand (StB 5772), the printed date of Blades's specimen is altered from 1793 to 1794. James Figgins's two specimens are recorded, but Reed adds a '?' which suggests that he was uncertain if Figgins *was* the owner of the second of them. Had he perhaps so far misinterpreted his notes as to create two specimens where only one existed? On the available evidence, it seems best to treat the specimen of '1794' and James Figgins's book of '5 pp.' as possible ghosts of Reed's creation.

93 Vincent Figgins 1801
Specimen of two-line letters cast by Vincent Figgins, West Street, West Smithfield, London. [At the foot:] T. Bensley, printer, Bolt Court, Fleet Street, 25 March, 1801.

1⁰. Berry & Johnson, p. 62; Supp. p. 36; Reed, p. 344.
Facsimile: V. Figgins, *Type specimens, 1801 and 1815*, ed. B. Wolpe (London, 1967).
Location: Wolpe.

94 Vincent Figgins 1802
Specimen of a fount of Telegú types, cast by Vincent Figgins, London. 1802.

2⁰. 4 leaves. Reed, p. 344.
Location: India Office Library, London; StB.

95 Vincent Figgins c. 1802
Specimen of a Telegú type, cast by Vincent Figgins, London. [At the foot:] T. Bensley printer.

1⁰. 30 × 24 cm.
Location: StB.
Probably the 'quarto' Telegú specimen referred to by Reed, p. 344.

96 Vincent Figgins 1815
Specimen of printing types, by Vincent Figgins, letter-founder, West Street, West Smithfield, London. 1815.

8⁰. Berry & Johnson, p. 63; Simmons 28.
Facsimile: V. Figgins, *Type specimens, 1801 and 1815*, ed. B. Wolpe (London, 1967).
Location: Col.UL (107 leaves); Enschedé (96 leaves); Harvard (95 leaves); OUP (120 leaves; 1817 watermark on 2 leaves); S.Bl (124 leaves; 1817 watermark on 7 leaves; dated 1820 on front board); Wolpe (79 leaves).

97 Vincent Figgins 1817
Newspaper founts cast by Vincent Figgins, letter founder, West Street, West Smithfield, London. 1817.

1⁰. Reed, p. 344.
Location: Col.UL (bound in **96**).

98 Vincent Figgins 1821
Specimen of printing types, by Vincent Figgins, letter-founder, West Street, West Smithfield, London. 1821.

8⁰. Berry & Johnson, p. 63.
Location: Col.UL (130 leaves); Harvard (134 leaves; dated 1822 on front board; 1822 and 1823 watermarks on some leaves; title leaf date altered in MS to 1823); StB (125 leaves; 2 leaves dated 1822; 1 leaf dated 1823).

99 Vincent Figgins 1824
Specimen of printing types, by Vincent Figgins, letter-founder, West Street, West Smithfield, London. 1824.

8⁰. 130 leaves. Berry & Johnson, p. 64.
Location: StB (1 leaf dated 1825).

100 Vincent Figgins c. 1824
Specimen of newspaper founts, cast by Vincent Figgins, letter-founder, London.

1⁰. 55 × 68 cm. Berry & Johnson, p. 64.
Location: StB (bound in **99**).

101 Vincent Figgins 1826
Specimen of printing types, by Vincent Figgins, letter-founder, West Street, West Smithfield, London. MDCCCXXVI.

8⁰. 146 leaves. Reed, p. 344; Berry & Johnson, p. 64.
Location: CUL (dated 1827 on front board).

102 Vincent Figgins 1827
Specimen of printing types, by Vincent Figgins, letter-founder, London. 1827.

8⁰. 37 leaves. Berry & Johnson, p. 64.
Location: StB.

103 Vincent Figgins 1828
Specimen of printing types, by Vincent Figgins, letter founder, West Street, West Smithfield, London. MDCCCXXVIII.

8⁰. 145 leaves. Berry & Johnson, p. 65.
Location: StB.

104 Vincent Figgins 1830
Specimen of printing types, by Vincent Figgins, letter founder, West Street, West Smithfield, London. MDCCCXXX.

8⁰. 158 leaves. Simmons 30.
Location: OUP.

105 Joseph Fry and Co. 1778

A specimen of printing types, by J. Fry and Co. letter-founders, in Queen-Street, near Upper-Moorfields, London, 1778.

1⁰. Simmons 36.
Location: OUP.

106 Joseph Fry and Co. 1780

A specimen of printing types, by J. Fry and Co. letter-founders, in Queen-Street, near Upper-Moorfields, London, 1780.

1⁰. Berry & Johnson, p. 39.
Location: BN; Bodl.

107 Joseph Fry and Sons 1785

A specimen of printing types, made by Joseph Fry and Sons, letter-founders, and marking-instrument makers, by the King's royal letters patent. London: printed in the year MDCCLXXXV.

8⁰. Berry & Johnson, p. 41.
Location: Amer.Ant.Soc (46 leaves); BL (53 leaves); CUL (57 leaves; title page is a variant setting ('A specimen of printing-types . . .') using different types. The advertisement is identical to that of **109**, save for one paragraph, which appears nowhere else); Newberry (46 leaves); StB (45 leaves).

108 Joseph Fry and Sons 1785

A specimen of printing types, by Joseph Fry and Sons, letter-founders, Worship-Street, Moorfields, London, 1785.

1⁰ (printed both sides). Berry & Johnson, p. 40; Simmons 37.
Location: BL; StB; etc.

In E. Chambers, *Cyclopaedia . . . with supplement and modern improvements by Abraham Rees* (London, 1786), vol. 3.

109 Joseph Fry and Sons 1786

A specimen of printing types, by Joseph Fry and Sons, letter-founders to the Prince of Wales. London: printed in the year MDCCLXXXVI.

8⁰. Berry & Johnson, p. 41.
Location: Amer.Ant.Soc (58 leaves); BL (58 leaves); Col.UL (60 leaves); CUL (58 leaves); Grolier (58 leaves); Harvard (58 leaves); King's College, London (58 leaves); S.Bl (2 copies, 58 and 57 leaves); Sohm; StB (58 leaves).

110 Edmund Fry and Co. 1787

A specimen of printing types, by Edmund Fry and Co. letter-founders to the Prince of Wales. London: printed in the year M DCC LXXXVII.

8⁰. Berry & Johnson, p. 43.
Location: Col.UL (60 leaves); CUL (60 leaves); Harvard (70 leaves); Newberry (60 leaves); StB (58 leaves).

111 Edmund Fry and Co. 1787

A specimen of printing types, by Edmund Fry and Co. letter-founders to the Prince of Wales. London: printed in the year M DCC LXXXVII.

8⁰. 44 p. Berry & Johnson, p. 42.
Location: BL; StB, etc.
In *The printer's grammar* (London, 1787), pp. 273–316.

112 Edmund Fry and Co. 1788

A specimen of printing types, by Edmund Fry and Co. letter-founders to the Prince of Wales. London: printed in the year M DCC LXXXVIII.

8⁰. Berry & Johnson, p. 43.
Location: Col.UL (62 leaves); CUL (70 leaves); Harvard (2 copies, 63 and 70 leaves); SFPL (70 leaves); S.Bl (72 leaves; T. B. Reed's copy, with annotations in his hand); StB (70 leaves).

113 Edmund Fry and Co. 1790

A specimen of printing types, by Edmund Fry and Co. letter-founders to the Prince of Wales. London: printed in the year MDCCXC.

8º. 72 leaves. Berry & Johnson, p. 44;
Simmons 34.
Location: OUP.

114 Edmund Fry and Co. 1790

A specimen of flowers, cast at the letter-
foundry of Edmund Fry and Co. Type-
Street, Chiswell-Street. London: printed in
the year MDCCXC.

8º. 17 leaves.
Location: Sohm.

115 Edmund Fry and Co. c. 1790

Type-Street, London. Edmund Fry and Co.
letter-founders to His Royal Highness the
Prince of Wales. Specimen of flowers. [At the
foot:] The ink made by J. Cooper, Bow-
Street, Covent-Garden, London. Printed by
S. Hazard, in Cheap-Street, Bath.

1º. Berry & Johnson, p. 44.
Facsimile: Berry & Johnson, pl. 8.
Location: not known.

116 Edmund Fry and Co. 1793

Specimen of metal cast ornaments, curiously
adjusted to paper, by Edmund Fry and Co.
letter-founders to the Prince of Wales, Type
Street. London: printed by T. Rickaby. 1793.

8º. 18 leaves. Berry & Johnson, p. 45.
Location: Amer.Ant.Soc.

117 Edmund Fry and Co. c. 1793

Fry's metal ornaments, continued.

1º. 54 × 34 cm.
Location: Amer.Ant.Soc.
A single sheet, showing ornaments 51 to 69,
with prices. Possibly the broadside specimen
reported by Berry & Johnson, p. 45.

118 Fry and Steele 1794

A specimen of printing types by Fry and
Steele, letter-founders to the Prince of Wales,
Type Street London: printed by T. Rickaby.
MDCCXCIV.

8º. Berry & Johnson, p. 45.
Location: Amer.Ant.Soc (103 leaves, plus 19
leaves of cast ornaments); BL (103 leaves);

Col.UL (104 leaves); CUL (84 leaves; a
mutilated copy, with the stubs of 17 leaves;
also includes specimen **119**; 23 leaves dupli-
cating part of the type specimen, probably
from another edition; 37 leaves of later types,
some dated 1804 and 1807 (cf. **131**)); Harvard
(103 leaves); Newberry (102 leaves); SFPL
(108 leaves).

119 Fry and Steele 1794

Specimen of metal cast ornaments, curiously
adjusted to paper, by Edmund Fry and Isaac
Steele, letter-founders to the Prince of Wales,
Type-Street. London: printed by T. Rickaby.
1794.

8º. Berry & Johnson, p. 45.
Location: Amer.Ant.Soc (28 leaves); BL (22
leaves); Col.UL (2 copies, 19 and 28 leaves);
CUL (2 copies, 22 leaves); Harvard (2 copies,
23 and 9 leaves); Newberry (19 leaves; i.e.
20 leaves, one of which is a folding leaf of
5-line Pica type); Prov.PL (22 leaves); SFPL
(20 leaves); StB (22 leaves); Yale (20 leaves).

120 Fry and Steele 1795

A specimen of printing types, by Fry and
Steele, letter-founders to the Prince of Wales,
Type-Street London: printed by T. Rickaby.
MDCCXCV.

8º. Berry & Johnson, p. 45.
Location: CUL (100 leaves); Harvard (103
leaves); Prov.PL (103 leaves); StB (103
leaves).

121 Fry, Steele and Co. 1798

A specimen of printing types, by Fry, Steele,
and Co. letter-founders to the Prince of Wales,
Type-Street. London: printed by T. Rickaby.
MDCCXCVIII.

8º. Berry & Johnson, p. 46.
Location: CUL (127 leaves); StB (129 leaves).

122 Fry, Steele and Co. 1799

A specimen of printing types, by Fry, Steele,
& Co. letter-founders to the Prince of Wales,
Type-Street. London printed by T. Rickaby.
MDCCXCIX.

8⁰. 129 leaves. Berry & Johnson, p. 46.
Location: StB.

123 Fry, Steele and Co. 1800
A specimen of printing types, by Fry, Steele
and Co. letter-founders to the Prince of Wales,
Type-Street. London: printed in the year
MDCCC.

8⁰. Berry & Johnson, p. 47; Simmons 37a.
Location: Amer.Ant.Soc (105 leaves); New-
berry (105 leaves); OUP (133 leaves); StB
(123 leaves).

124 Fry, Steele and Co. 1801
A specimen of printing-types, by Fry, Steele
and Co. letter-founders to the Prince of Wales,
Type-Street. London: printed in the year
MDCCCI.

8⁰. 134 leaves. Berry & Johnson, p. 47.
Location: Col.UL.

125 Fry, Steele and Co. 1802
A specimen of printing-types, by Fry, Steele
and Co., letter-founders to the Prince of Wales,
Type-Street. London. Printed in the year
MDCCCII.

8⁰. Simmons 38.
Location: OUP (98 leaves); Sohm.

126 Fry, Steele and Co. 1803
A specimen of printing-types, by Fry, Steele
and Co. letter-founders to the Prince of Wales,
Type-Street. London. Printed in the year
MDCCCIII.

8⁰. Reed, p. 314.
Location: CUL (156 leaves); S.Bl (129 leaves).

127 Fry and Steele 1805
Specimen of metal cast ornaments, curiously
adjusted to paper, by Fry and Steele, letter-
founders to the Prince of Wales, Type-Street.
London: printed in the year MDCCCV.

8⁰. 25 leaves. Berry & Johnson, p. 47.
Location: StB.

128 Fry and Steele 1806
[On wrapper:] A specimen of modern cut
printing types by Fry and Steele, letter-
founders to the Prince of Wales, Type-Street.
London; printed in year 1806.

8⁰. 25 leaves.
Location: Harvard (several leaves dated 1807).

129 Fry and Steele 1808
A specimen of modern cut printing-types by
Fry and Steele, letter-founders to the Prince
of Wales, Type-Street. London, printed in the
year 1808.

8⁰. 94 leaves.
Location: S.Bl.

130 Fry and Steele 1808
Specimens of modern-cut printing types,
from the [foundry] of Messrs. Fry and Steele

8⁰. 19 p. Berry & Johnson, p. 47; Simmons 39.
Location: BL; StB; etc.
In C. Stower, *The printer's grammar* (London,
1808), pp. [531–50]. Pp. 99–127 show flowers
from Fry and Steele's foundry. Facsimile
reprint, 1965.

131 Fry and Steele 1804–10
[Collected specimens of printing types.]

[1]. 8⁰. 118 leaves. Berry & Johnson, p. 47;
Gray, p. 186.
Location: Col.UL (Sp Coll Bk Arts Z250 F
94 1808).

[2]. 8⁰. 118 leaves. Berry & Johnson, p. 47;
Gray, p. 186.
Location: Col.UL (Sp Coll Bk Arts Z250 F
94 1810; leaf 35 bears MS. note, 'Fry, Steele
& Co's specimens presented to Rich: Ronald-
son 1810').

[3]. 8⁰. 54 leaves. Gray, p. 186.
Location: StB (10627; includes leaves dated or
watermarked 1804, 1805, 1807, 1808, 1810).

132 Fry and Steele 1814
[On wrapper:] A specimen of modern cut
printing types by Fry and Steele, letter-

founders to the Prince Regent, Type Street, London. 1814.

8⁰. Supp. p. 35.
Location: Prov.PL (48 leaves); Vt.UL (59 leaves).

133 Fry and Steele c. 1814–16
Fry and Steele's specimen of printing types.

4⁰. 8 p. Berry & Johnson, p. 48; Simmons 40.
Location: BL; StB; etc.

In A. Rees, *Cyclopaedia* (London, 1819), vol. 28, s.v. 'Printing'. See Simmons, p. 409, for a note on the dating of this and the other specimen (**217**) in Rees's *Cyclopaedia*.

134 Edmund Fry 1816
Specimen of printing types, by Edmund Fry, letter founder to the King, and Prince Regent, Type Street. London. 1816.

8⁰. Berry & Johnson, p. 48.
Location: BL (101 leaves); BN (120 leaves); Bodl. (103 leaves); Col.UL (101 leaves); Newberry (100 leaves); Prov.PL (99 leaves); SFPL (99 leaves); S.Bl (86 leaves; 1817 watermark on 4 leaves); StB (98 leaves; slip dated April 1819 pasted on title, announcing a new edition 'at press').

135 Edmund Fry and Son 1820
Specimen of modern printing types by Edm. Fry & Son, letter founders to the King, Type Street. London. M.DCCC.XX.

8⁰. Berry & Johnson, p. 49.
Location: Col.UL (118 leaves); CUL (102 leaves; 2 leaves dated 1821); OUP (100 leaves); V&A (91 leaves).

136 Edmund Fry and Son 1823
Specimen of modern printing types, by Edm. Fry & Son, letter founders to the King, Type Street. London. 1823. Barnard, imp.

4⁰. Berry & Johnson, p. 49.
Location: Col.UL (118 leaves); Harvard (117 leaves); Leipzig; Vt.UL (123 leaves).

137 Edmund Fry 1824
Specimen of modern printing types, by Edmund Fry, letter founder to the King, Type Street. London. 1824. Maurice, imp.

8⁰ and 4⁰. Berry & Johnson, p. 50.
Location: B'ham.RL (146 leaves; date on title page altered in MS, to 1828); BL (143 leaves; date on title page altered in MS. to 1827); Bodl. (115 leaves); Col.UL (3 copies, 135, 145, 149 leaves; date on title page of copy 1 altered in MS. to 1827, of copy 3 to 1828); CUL (2 copies, 137 and 140 leaves); Enschedé (137 leaves); Harvard (133 leaves); Newberry (129 leaves); SFPL (137 leaves); StB (2 copies, 115 and 124 leaves).
The number of leaves in each specimen listed above includes a section of ornaments printed on both sides of the leaf in some copies.

138 Edmund Fry 1825
Diamond. Edmund Fry. March, 1825.

1⁰. Berry & Johnson, p. 51.
Location: CUL (bound in **137**).

139 Edmund Fry 1827
Fry's newspaper specimen. Edmund Fry, letter founder in ordinary to the King, by special appointment. Polyglot Foundery, Type Street, 1827.

1⁰. Berry & Johnson, p. 51.
Location: Col.UL (bound in **137**); Enschedé (bound in **137**).

140 Edmund Fry 1828
Specimen of modern printing types, by Edmund Fry, letter founder to the King, Type Street, 1828.

8⁰. 145 leaves.
Location: StB.

141 Grover foundry? c. 1690
[Specimen of printing types.]

1⁰. Berry & Johnson, p. 3.
Location: BL (463. h. 11., no. 295).

The top margin is inscribed 'By Glover', probably in the hand of Joseph Ames (for Ames's habit of misspelling the name of Grover, see Mores, p. 45). The attribution is dubious. Carter and Ricks (Mores, p. 45n.) suggest that Ames was mistaken, since the types shown do not match the list of Grover's materials given by Mores.

142 Hugh Hughes after 1823

A specimen of book and newspaper printing types by Hugh Hughes, letter cutter and founder, 23, Dean Street, Fetter Lane.

8°. 16 leaves. Berry & Johnson, p. 83.
Location: StB.

143 Hugh Hughes after 1823

[On wrapper:] Specimen sheet of modern music types by H. Hughes, 23 Dean Street, Fetter Lane, together with a scheme of music cases.

8°. Reed, p. 364.
Location: not known.

144 Joseph Jackson c. 1765

[Specimen of one fount.]
J. Nichols, *Literary anecdotes* (London, 1812–16), vol. 2, p. 360.

Location: not known.
The conjectural date is supplied by Reed, p. 329.

145 Joseph Jackson 1773?

[Specimen of flowers.]

8°. 19 × 12 cm. 7 leaves.
Location: StB (20293).

This anonymous fragment on laid paper is apparently the last part of a type specimen book. It shows 94 flowers in 11 sizes. All save 6 of them reappear in the specimen book that William Caslon issued in 1796 (**77**) after his acquisition of Jackson's foundry. The account of Jackson's material given by Mores, p. 78, appears to be based on a specimen issued in 1773.

146 Joseph Jackson c. 1785?

Specimen of the Nagri type preparing for Captain Kirkpatrick's Hindvi grammar and dictionary.

1°.
Location: StB.

Kirkpatrick's prospectus, *Account of the plan and contents of the new Hindvi grammar and dictionary*, dated 20 January 1785, remarks that the Nagri type, 'owing to certain unforseen, but unavoidable accidents, is yet unfinished'. In the event, the grammar was not published until 1799. Of the two undated specimens showing Jackson's type, **147** is more complete than **146**.

147 Joseph Jackson c. 1785?

Specimen of the Deo Nagri or Hindvi type, cut for the purpose of printing a grammar and dictionary of that language, under the inspection of William Kirkpatrick, Captain in the service of the Honourable East-India Company, and Persian Secretary to the Commander in Chief in India, by Joseph Jackson, letter founder, Salisbury Court, Fleet Street.

1°. Reed, p. 329; Supp. p. 34.
Location: CUL.

148 John James 1748

A specimen of musick by John James, letter founder in Bartholomew Close, London, 1748. Purcell's, Fairest isle all isles excelling.

1°.
Location: not known.
'A large folio single sheet' (W. C. Smith and C. Humphreys, *Music publishing in the British Isles* (London, 1954), p. 192).

149 John James 1782

A catalogue and specimen of the large and extensive printing-type-foundery of the late ingenious Mr. John James, letter-founder, formerly of Bartholomew-Close, London, deceased: including several other founderies, English and foreign. Improved by the late reverend and learned Edward Rowe Mores,

deceased: comprehending a great variety of punches and matrices of the Hebrew, Samaritan, Syriac, Arabic, Aethiopic, Alexandrian, Greek, Roman, Italic, Saxon, Old English, Hibernian, Script, Secretary, Court-hand, Mathematical, Musical, and other characters, flowers, and ornaments; which will be sold by auction, by Mr. Paterson, at his Great Room (No. 6), King's-Street, Covent-Garden, London, on Wednesday, 5th June, 1782; and the three following days . . .

8°. 24 p., 48 leaves. Berry & Johnson, p. 4.
Facsimile: Mores.
Location: Grolier; Prov.PL.

48 leaves of type specimens.

150 Robert Lothian 1806

Specimen of printing types by R. Lothian letter-founder [] 1806.

8°. 16 leaves. Maurice Annenberg, *Type foundries of America and their catalogs* (Baltimore, 1975), p. 177.
Location: Harvard.

Two excisions, the location of which is indicated in the transcription above by square brackets, have been made in the title leaf, the purpose being apparently to remove the location of the foundry and the place of issue of the specimen, together with a printer's imprint. Robert Lothian is recorded as a typefounder in the Edinburgh directories for 1804–6 and is supposed to have emigrated to New York. There is evidence, however, that he was in Boston for a time. In 1805 a Boston printer bought type from a founder named 'Lothian', and Robert Lothian, type-founder, advertised in a Boston newspaper in 1807. (See Rollo G. Silver, *Typefounding in America 1787–1825* (Charlottesville, 1965), p. 46; 'Belcher and Armstrong set up shop', *Studies in Bibliography*, vol. 4 (1951–2), pp. 201–4.) There is no conclusive evidence that indicates where this specimen was printed, and although MS. notes in this copy suggest that it was in the hands of an American owner

in 1806, one of the devices shown (a seal for the Commissioners of Northern Lighthouses) is of purely Scottish significance. The analogy of the Baine specimen of 1787 (**5**), suggests that Lothian may have prepared his specimen at home before emigrating.

151 Robert Martin c. 1780

A specimen by Robert Martin, Birmingham.

1°. Berry & Johnson, p. 32.
Facsimiles: Monotype recorder, no. 209–10 (Sep–Dec 1925), p. 38; *The Fleuron*, no. 5 (1926), p. 70 (both reduced).
Location: CUL.

Berry & Johnson assigned a date of 'c. 1775' to this specimen on the assumption that Martin, early in his career as an independent printer, had acquired a stock of types by Baskerville. The types shown are not Baskerville's, however (as I am grateful to Mr. David McKitterick for pointing out), but were probably cut by Martin himself. They come into use in his printing gradually, so the date c. 1780, suggested in the *Monotype recorder*, is a more plausible one.

152 John Matthewson c. 1810

Specimen of printing types, cut and cast by John Matthewson, letter-founder, Edinburgh.

4°. 2 leaves. Berry & Johnson, p. 73; Supp. p. 37.
Location: Col.UL.

153 William Miller and Co. 1809

[Specimen of printing types.]
Bigmore & Wyman, vol. 2, p. 42.
Location: not known.

154 William Miller and Co. 1811

Specimen of printing types, by William Miller & Co. letter-founders, Edinburgh. Edinburgh: printed by A. Balfour. 1811.

4°. 19 leaves.
Location: Vt.UL.

155 William Miller and Co. 1813
Specimen of printing types, by William Miller & Co. letter-founders, Edinburgh. Edinburgh: printed by A. Balfour. 1813.

4°. 24 leaves. Berry & Johnson, p. 73.
Location: StB.

156 William Miller and Co. 1814
Specimen of printing types, by William Miller & Co. letter-founders, Edinburgh. Edinburgh: printed by A. Balfour. 1814.

4°. Berry & Johnson, p. 73.
Location: NLS (2 copies, 27 and 29 leaves); StB (29 leaves).

157 William Miller and Co. 1815
Specimen of printing types, by William Miller & Co. letter-founders, Edinburgh. Glasgow: printed at the Stanhope Press, by R. Chapman. 1815.

4°. Berry & Johnson, p. 74; Simmons 44.
Location: NLS (31 leaves); OUP (34 leaves; some leaves dated 1816).

158 William Miller 1822
Specimen of printing types, by William Miller, letter-founder to His Majesty for Scotland. Edinburgh: printed by James Ballantyne & Co. 1822.

4°. Berry & Johnson, p. 74.
Location: NLS (53 leaves); StB (52 leaves); Vt.UL (66 leaves).

159 William Miller 1822
Specimen of printing types, by William Miller, letter-founder to His Majesty for Scotland. Edinburgh: printed by Oliver & Boyd. 1822.

4°.
Location: S.Bl (69 leaves); StB (71 leaves).

160 William Miller c. 1830
Specimen of newspaper founts.
By William Miller, Edinburgh, letter-founder to His Majesty for Scotland. [At the foot:] Oliver and Boyd, printers.

1°. Berry & Johnson, p. 75.
Location: not known.

161 Robert Mitchell c. 1700
[Specimen of Canon italic.]
[At the foot:] Robert Mitchel.

1°. Berry & Johnson, p. 3.
Location: BL (463. h. 11., no. 296).

162 Isaac Moore and Co. 1766
A specimen by Isaac Moore and Co. letter-founders, in Bristol, 1766.

1°. Berry & Johnson, p. 38.
Facsimile: D. B. Updike, *Printing types* (1922), fig. 276 (reduced).
Location: Prov.PL.

This sheet was formerly in the collection of A.A. Renouard, and is almost certainly the specimen listed as 'Bristol, 1768' in his *Catalogue de la bibliothèque d'un amateur* (Paris, 1819), 1, p. 310, and cited by Reed, p. 313, and Berry & Johnson, p. 39. It corresponds exactly with the physical details given by Renouard: 'grande feuille collée sur une toile ou batiste fine, bordée d'un ruban de soie jaune'.

163 Isaac Moore and Co. 1768
A specimen of printing-types, by Isaac Moore and Co. letter-founders, in Queen-Street near Upper-Moorfields, London, 1768.

1°. Berry & Johnson, p. 38.
Facsimile: Biblis (Stockholm, 1958).
Location: Sohm.

164 Isaac Moore and Co. 1770
A specimen of printing types by Isaac Moore and Co., letter-founders in Queen Street, near Upper Moorfields, London. 1770.

1°. Caxton Celebration Catalogue no. 4371; Berry & Johnson, p. 39.
Location: not known.

The contents of this specimen are recorded in a note pencilled by T. B. Reed in his copy of the specimen of Edmund Fry and Co., 1788 (**112**, now S.Bl). It added these types to those

shown in 1768: 8-line Pica rom., 6-line Pica rom., Pica no. 2 rom. and ital., Small Pica rom. and ital., Nonpareil rom. and ital., Pearl rom. and ital.

165 Joseph Moore c. 1785?

A specimen of printing types, by J. Moore, letter-founder, no. 43, Drury-Lane.

1°. Berry & Johnson, p. 39; Reed-Johnson, p. 300.
Location: BN.

Berry & Johnson's suggested date for this specimen is c. 1770. The Westminster Rate Books show that Joseph Moore, successor to Isaac Moore, occupied 43 Drury Lane from 1781 to 1787.

166 Joseph Moxon 1669

Proves of several sorts of letters cast by Joseph Moxon. [At the foot of column 2:] Westminster printed by Joseph Moxon, in Russel Street, at the signe of Atlas. 1669.

1°. Berry & Johnson, p. 3.
Facsimile: J. Moxon, *Mechanick exercises on the whole art of printing*, ed. H. Davis and H. Carter (London, 1962).
Location: BL (Harley 5915, no. 459); Magd. Coll.Camb.

167 Nicholas Nicholls c. 1665

Augustissimo monarchae & serenissimo principi & domino Carolo IIdo Britanniarum, & Franciae regi gloriosissimo fidei defensori, &c. Haec vota sequentia Vivas O rex in perpetuum. [There follow 7 lines in Hebrew, Syriac, Samaritan, Ethiopic, and Arabic types.] Ut cordis devotissimi anhelitus artisque suae specimen, sacratissime vestrae majestati humillime offert, & dedicat maximi regis subditorum minimus, Nicholas Nicholls.

1°. 29 × 21 cm overall; type area 7.2 × 4 cm. Berry & Johnson, p. 2.
Facsimile: Reed, fig. 43; Reed-Johnson, fig. 35 (enlarged).
Location: PRO (State Papers, Dom., 1665, vol. 142, no. 174).

Submitted with Nicholls's petition for the appointment of letter founder to the King, which is reprinted in Reed-Johnson, p. 164. The transcription of the text in Berry & Johnson and the facsimile in Reed-Johnson are corrupt.

168 Nicholas Nicholls? c. 1665?

[Specimen of Anglo-Saxon, black-letter and roman type.]

1°.
Facsimile: Mores, p. lxxv.
Location: BL (Harley 5977, no. 200).

Anonymous. Attributed to Nicholls by Carter and Ricks (Mores, p. lxxi). However, the Great Primer on this sheet is not the type linked with Nicholls's name among the materials at the Oxford University Press.

169 Oxford University Press c. 1687

[Specimen of printing types.]

8°. 12 leaves. S. Morison, *John Fell* (Oxford, 1967), p. 229.
Facsimile: ibid. pl. 7–12.
Location: Barker; Ch.Ch.

For a full record of specimens **169–72**, see J. S. G. Simmons, 'The Fell type specimens', in S. Morison, *John Fell* (Oxford, 1967), pp. 229–32. For specimens **170–8**, see also Hart.

170 Oxford University Press 1693

A specimen of the several sorts of letter given to the university by Dr. John Fell late Lord Bishop of Oxford. To which is added the letter given by Mr. F. Junius. Oxford, printed at the Theater A.D. 1693.

8°. 20 leaves. Berry & Johnson, p. 6.
Facsimile: London, 1928.
Location: Bodl. (3 copies); Col.UL; CUL; Magd.Coll.Camb; Trin.Coll.Camb.; Vt.UL (18 leaves).

171 Oxford University Press 1695

A specimen of the several sorts of letter given to the university by Dr. John Fell sometime Lord Bishop of Oxford. To which is added the

letter given by Mr. F. Junius. Oxford, printed at the Theater A.D. 1695.

8⁰. 22 leaves (first issue); 24 leaves (second issue). Berry & Johnson, p. 6; Simmons 48, 49.
Location: First issue: Bodl.; CUL; Huntington; McGill; OUP (2 copies); Yale. Second issue: All Souls; BL; BN; Bodl. (2 copies); Newberry; OUP; Prov.PL; Trin.Coll.Camb.

172 Oxford University Press 1706
A specimen of the several sorts of letter given to the university by Dr. John Fell sometime Lord Bishop of Oxford. To which is added the letter given by Mr. F. Junius. Oxford, printed at the Theater A.D. 1706.

8⁰. 26 leaves. Berry & Johnson, p. 7; Simmons 50.
Location: BL; Bodl.; Col.UL; CUL; Harvard; OUP (2 copies).

173 Oxford University Press 1757–8
A specimen of several sorts of letters in the University Printing-House, Oxford.

1⁰. Berry & Johnson, p. 8; Supp. p. 31; Simmons 52.
Facsimile: The Library, 5th series, vol. 11 (1956), facing p. 16.
Location: Bodl.; OUP.

The suggested date in Berry & Johnson is c. 1710. For the revised dating, see J. S. G. Simmons, 'The undated Oxford broadsheet specimen', *The Library*, 5th series, vol. 11 (1956), pp. 11–17.

174 Oxford University Press 1768
A specimen of the several sorts of printing-types belonging to the university of Oxford at the Clarendon Printing-House. M DCC LXVIII.

8⁰. 34 p. Berry & Johnson, p. 8.
Location: All Souls; BL; Harvard; King's College, London; StB; Yale.

175 Oxford University Press 1770
New letters purchased in the years 1768,

1769, 1770. [At the foot of p. 6:] Clarendon-Press, Sept. 29. 1770.

8⁰. 6 p.
Location: All Souls; BL; Harvard; King's College, London; StB; Yale.

Issued with **174**.

176 Oxford University Press 1775
New letters purchased in the years 1771, 1772, 1773, 1774. [At the foot of p. 4:] Clarendon-Press, June 1, 1775.

8⁰. 4 p. Berry & Johnson, p. 9.
Location: All Souls; Kings College, London. Issued with **174**.

177 Oxford University Press 1786
A specimen of the several sorts of printing-types belonging to the university of Oxford at the Clarendon Printing-House. MDCCLXXXVI.

8⁰. 36 leaves. Berry & Johnson, p. 9; Simmons 53.
Location: BN; OUP; StB.

178 Oxford University Press 1794
A specimen of the several sorts of printing-types belonging to the university of Oxford, at the Clarendon Printing-House. MDCCXCIV.

8⁰. 47 leaves. Berry & Johnson, p. 10; Simmons 54.
Location: Bodl. (10 leaves); Harvard; OUP.

179 Stephen Parker 1769
A specimen of printing types, by Stephen Parker, letter-founder, Dublin. Printed by Robert Marchbank, MDCCLXIX.

8⁰. 18 leaves. Berry & Johnson, p. 52.
Location: NL Ireland.

180 Louis Jean Pouchée 1819
Specimens of printing types by L. I. Pouchée, at the new foundry, Great Wild Street, Lincoln's Inn Fields, London. 1819.

8⁰. 43 leaves. Berry & Johnson, p. 80.
Location: StB.

181 Pouchée and Jennings 1821

[On wrapper:] A continuation of specimens of the fonts of modern printing types completed to 1821. at the new type foundry of Pouchée & Jennings, in Great Wild Street, London.

8º.

Location: S.Bl (53 leaves); Vt.UL (55 leaves, including the title leaf of **180**).

182 Pouchée and Jennings 1822

[On wrapper:] A continuation of specimens of the fonts of modern printing types completed to 1822. at the new type foundry of Pouchée & Jennings, in Great Wild Street, London.

8º. 7 leaves.
Location: S.Bl.

183 Louis Jean Pouchée 1823

Specimens of printing type by L. I. Pouchée at the new foundry, Little Queen Street, Lincoln's Inn Fields, London. 1823.

8º. Supp. p. 37.
Location: Col.UL (76 leaves; price list of 1 Oct 1825; cover title: Continuation of specimens of the fonts of modern printing types completed to 1824. At the type foundry of L. I. Pouchée, in Little Queen Street, London.); Prov.PL (183 leaves; a made-up volume, with leaves from Caslon, Figgins and Thorowgood specimens).

184 Louis Jean Pouchée 1827

Specimens of printing types by Louis I. Pouchée. Queen Street, London. 1827.

8º. 84 leaves. Berry & Johnson, p. 81.
Location: OUP.

185 Matthew Urlwin Sears 1825

Specimen of stereotype ornaments for the use of printers in general, by M. U. Sears, engraver on wood, no. 8, Angel Terrace, Islington, near the City Road. 1825. W. Sears, printer, 45, Gutter Lane, Cheapside, London.

4º. 23 leaves.
Location: StB.

Advertisement and price list dated 24 June 1826. Includes large ornamented types.

186 Slater, Bacon and Co. 1809

1809 A specimen of improved printing types, cast by Slater, Bacon and Co. printers and letter founders Sheffield.

obl. 8º. 39 leaves. Berry & Johnson, p. 71.
Location: Col.UL (leaf 3 is the title leaf of specimen **30**, Bower, Bacon and Bower, 1810).

187 Simon Stephenson 1790

This specimen of the original printing types of Stephenson's British Letter Foundry, is, with the utmost deference, submitted to the public. Should the proprietor be so fortunate as to experience their approbation and patronage, he will ever be found grateful to acknowledge, and industrious to deserve them. [At the foot:] The letter of this foundry is the deepest cut of any in the world. William Coleman, regulator. Richard Austin, punch-cutter. Simon Stephenson, letter founder, Breams Buildings, Chancery Lane, London. 1790.

1º. 42 × 28 cm.
Location: StB.

188 Simon Stephenson 1791

A specimen of printing types by S. Stephenson, letter founder, British Foundry, Breams Buildings, Chancery Lane. The matrices are entirely new, and executed from original punches cut by Richard Austin. London; printed by J. Jarvis. 1791.

8º. 18 leaves. Berry & Johnson, p. 60.
Location: Col.UL.

189 Simon and Charles Stephenson 1796

First part of a specimen of printing types, cast at the foundry of S. & C. Stephenson, Breams Buildings, Chancery Lane. The punches cut by R. Austin. London: 1796. The specimens of English, Pica, and Minion, are at press. Orders for printers' jointers'

work, and every article requisite in a printing office, will be carefully and expeditiously executed.

8º. 29 leaves. Berry & Johnson, p. 60.
Location: Col.UL; Harvard; StB.

190 Simon and Charles Stephenson 1796
A specimen of printing types and various ornaments for the embellishment of press work, by S. & C. Stephenson, British Foundry, Breams Buildings, Chancery Lane. The punches by Richard Austin. London: printed by A. Macpherson. 1796.

8º. Berry & Johnson, p. 61.
Location: Harvard (56 leaves); Sohm; StB (53 leaves).

Advertisement, leaf 3, dated February 1797.

191 Myles Swinney c. 1790?
Specimen of part of the Phoenix Foundry, by M. Swinney, Birmingham.

1º. Supp. p. 37.
Location: Prov.PL.

This undated sheet shows types modelled on Baskerville's, some of which are found in Swinney's printing from 1785 onwards. All save one were omitted from the specimen book of 1802 (**192**, below).

192 Myles Swinney 1802
Specimen of part of the printing types cast by Myles Swinney, Birmingham. Swinney and Hawkins, printers, Birmingham.

8º. 22 leaves. Berry & Johnson, p. 71.
Location: B'ham.RL (price list dated 1802; 5 leaves dated Jan 1802).

193 Robert Thorne 1794
Specimen of printing types, by R. Thorne, letter-founder, no. 11, Barbican. London. Printed by W. Glindon 1794.

8º. 11 leaves. Berry & Johnson, p. 66.
Location: S.Bl.

194 Robert Thorne 1798
Specimen of printing types, by R. Thorne,

letter founder, Barbican. London, printed in the year 1798.

8º. 47 leaves. Berry & Johnson, p. 66; Simmons 58.
Location: OUP.

195 Robert Thorne 1803
[Original label laid down on later board:] Thorne's specimen of printing types.

8º. 22 leaves. Berry & Johnson, p. 67.
Location: StB (advertisement dated 1803).

196 Robert Thorne 1810
[Title supplied in MS:] Thornes specimen 1810 Fann Street near Barbican London.

8º. 47 leaves.
Location: Barker (bound with Stower, *Printer's grammar* (1808) and a specimen of Caslon and Catherwood, 1805).

197 Robert Thorne c. 1813
Specimen of Long Primer, Burgeois, Brevier, & Minion, for newspapers and general purposes, by Robt. Thorne, letter founder, Fann Street, near Barbican, London.

1º. Simmons, 59.
Location: OUP.

198 Robert Thorne 1814
[On partly defective wrapper:]
[Spec]imen of modern cut printing types, by Robert Thorne, letter founder, Fann Street, near Barbican, London. Printed in the year 1814.

8º.
Location: S.Bl (wrapper only).
The contents of this specimen have not been found.

199 Robert Thorne c. 1815
Two line Pica script. Robert Thorne, letter founder.

1º. Berry & Johnson, p. 67.
Location: not known.

This entry, like **82** and **83**, above, was transcribed by Berry & Johnson from the *Catalogue of the books in the library of the Typothetae of New York* (New York, 1896). Possibly a leaf detached from a type specimen book.

200 William Thorowgood 1820
Thorowgood, (late Thorne,) letter founder, Fann-Street, near Barbican, London. 1820.

8⁰. 86 leaves. Berry & Johnson, p. 67; Birrell & Garnett 89.
Location: not known.

201 William Thorowgood 1821
1821. Thorowgood's new specimen of printing types, late R. Thorne's, no. 2, Fann Street, Aldersgate Street, London. A liberal discount on export orders.

8⁰. Berry & Johnson, p. 67.
Location: S.Bl (134 leaves); StB (2 copies, 120 and 128 leaves).

202 William Thorowgood 1822
1822. Thorowgood's new specimen of printing types, late R. Thorne's; no. 2, Fann Street, Aldersgate Street, London. A liberal discount on export orders.

8⁰. Berry & Johnson, p. 68; Supp. p. 36.
Location: Col.UL (132 leaves; front board dated 1823; title date altered in MS. to 1823; price list of 1 Feb 1825); V&A (129 leaves).

203 William Thorowgood 1822
[A specimen sheet of Greek type, W. Thorowgood, June 1822.]

1⁰. Berry & Johnson, p. 68; Reed, p. 297.
Location: not known.

204 William Thorowgood 1824
New specimen of printing types from the Fann Street Letter Foundry London. W. Thorowgood, letter founder to His Majesty. Late Thorne. A liberal discount on export orders. 1824.

8⁰. 161 leaves. Supp. p. 36.
Location: Prov.PL.

205 William Thorowgood 1825
New specimen of printing types, from the Fann-Street Letter Foundry London. W. Thorowgood, letter founder to His Majesty. Late Thorne. A liberal discount on export orders. 1825.

8⁰. Berry & Johnson, p. 68.
Location: Col.UL (166 leaves); StB (191 leaves).

206 William Thorowgood 1827
A specimen of the printing types, in the Fann-Street Letter Foundery, London. W. Thorowgood, letter-founder to His Majesty late Thorne. A liberal discount on export orders. 1827.

8⁰. 174 leaves. Berry & Johnson, p. 69.
Location: Col.UL.

207 William Thorowgood 1828
[On the front board, now discarded:] Thorowgood's new type specimen 1828.

8⁰. 172 leaves. Berry & Johnson, p. 69.
Location: StB.

208 William Thorowgood 1829
Thorowgood's new specimen of modern type in the Fann-Street Letter Foundry, London. A liberal discount allowed to merchants or shippers, on all orders for exportation. Letter founder to His Majesty. G. Balne, printer, 38 Gracechurch Street, London.

8⁰. Supp. p. 36.
Location: CUL (170 leaves); Col.UL (175 leaves).

209 William Thorowgood 1830
[On the front wrapper:] Additions to the specimen of the Fann Street Letter Foundry, London. W. Thorowgood, letter founder to His Majesty. A new edition of the Greeks, Hebrews, and foreign characters, of the Polyglot Foundry, late the property of Dr. Fry, is in preparation. 1830.

8⁰. 19 leaves. Berry & Johnson, p. 70.
Location: StB.

210 William Thorowgood 1830
Fann Street Letter Foundry, London.
Thorowgood's specimen of Greek, Hebrew,
and foreign characters, late the property of
Dr. Edmund Fry. London: 1830.

8⁰. 5 leaves. Berry & Johnson, p. 70; Caxton
Celebration Catalogue, no. 4413; Bigmore &
Wyman, 3, p. 11.
Location: not known.

211 Alexander Wilson and Sons 1772
A specimen of some of the printing types cast
in the foundery of Doctor A. Wilson and
Sons. College of Glasgow, M.DCC.LXXII.

8⁰. 24 leaves. Berry & Johnson, p. 52.
Location: BL; Harvard.

212 Alexander Wilson and Sons 1783
A specimen of printing types. [At the foot:]
The above are some of the sizes cast in the
letter foundery of Dr. Alex. Wilson & Sons.
Glasgow. 1783.

1⁰. Berry & Johnson, p. 53.
Location: BL; StB; etc.

In E. Chambers, *Cyclopaedia ... with sup-
plement and modern improvements by Abraham
Rees* (London, 1786), vol. 3. There are three
variant states.

213 Alexander Wilson and Sons 1786
A specimen of printing types cast in the letter
foundery of Alexander Wilson and Sons.
Glasgow. MD.CC.LXXXVI.

4⁰. 51 leaves. Berry & Johnson, p. 53.
Location: Col.UL; StB.

214 Alexander Wilson and Sons 1789
A specimen of printing types cast in the letter
foundery of Alexander Wilson and Sons.
Glasgow. MD.CC.LXXXIX.

4⁰. 52 leaves. Berry & Johnson, p. 54.
Location: Amer.Ant.Soc; Col.UL; Harvard;
OUP (51 leaves); StB.

215 Alexander Wilson and Sons 1812
A specimen of modern cut printing types, by

Alex. Wilson & Sons, letter founders, Glasgow.
James Hedderwick and Co. printers, Bell-
Street, Glasgow. 1812.

4⁰. 34 leaves. Berry & Johnson, p. 54.
Location: StB.

216 Alexander Wilson and Sons 1815
A specimen of modern cut printing types, by
Alex. Wilson & Sons, letter founders, Glasgow.
Printed for A. Wilson and Sons, College,
Glasgow. 1815.

4⁰. Berry & Johnson, p. 54.
Location: Col.UL (49 leaves); NYPL (62
leaves, some watermarked 1818 and 1819);
Vt.UL (50 leaves).

217 Alexander Wilson and Sons c. 1814–17
Specimen of printing types, by Alexander
Wilson & Sons, letter founders, Glasgow.

4⁰. 8 p. Berry & Johnson, p. 55; Simmons 61.
Location: BL; StB; etc.

In A. Rees, *Cyclopaedia* (1819), vol. 28, s.v.
'Printing'. See Simmons, p. 409, for a note on
the dating of this specimen.

218 Alexander Wilson and Sons 1823
Specimen of modern printing types, by Alex.
Wilson and Sons. Glasgow. 1823.

4⁰. 87 leaves. Berry & Johnson, p. 55.
Location: StB.

219 Alexander Wilson and Sons 1826
Specimen of modern printing types, by Alex.
Wilson and Sons, letter-founders, Glasgow.
1826.

4⁰.
Location: Col.UL (97 leaves); StB (86 leaves;
1 leaf dated 1827).

220 Alexander Wilson and Sons 1828
Specimen of modern printing types, by Alex.
Wilson and Sons, letter founders, Glasgow.
1828.

4⁰. Berry & Johnson, p. 55; Simmons 62.
Location: Newberry (72 leaves; lacks title leaf,
but one leaf dated 1828); OUP (75 leaves).

Printers' specimens

P1 Heirs and successors of Andrew Anderson 1698
A true account of the types of His Majesties printing-house, belonging to the heirs and successors of Andrew Anderson, His Majesties printer; consisting of several sorts. All added since the year 1694. [At the foot of column 3:] Edinburgh, printed by the heirs and successors of Andrew Anderson, printer to the King's most excellent Majesty, city and colledge, anno dom. 1698.

1°. A. F. Johnson, 'An unrecorded specimen sheet of a Scottish printing house', *Transactions of the Edinburgh Bibliographical Society*, vol. 1, part 1 (1936), pp. 61–4; reprinted in A. F. Johnson, *Selected essays* (Amsterdam, 1970), pp. 314–15; Supp. p. 37.
Facsimile: A. F. Johnson, op. cit.
Location: NLS.

P2 Anonymous c. 1650
[MS. endorsement:]
A specimen of severall latine alphabets.

1°. Berry & Johnson, p. 84.
Facsimile: Berry & Johnson, plate 19.
Location: University Archives, Oxford (S.E.P./P/17b/4).

P3 Anonymous c. 1700?
[Specimen of printing types.]

1°. 31 × 39 cm. Reed-Johnson, p. 180.
Facsimile: *Typography*, no. 6 (1938), p. 18; A. F. Johnson, *Selected essays* (Amsterdam, 1970), p. 306 (reduced).
Location: BL (Harley 5915, no. 37).

P4 Anonymous c. 1700?
[Specimen of printing types.]

1°. Reed-Johnson, p. 180.
Facsimile: *Signature*, no. 3 (1936), p. 19 (incomplete); A. F. Johnson, *Selected essays* (Amsterdam, 1970), p. 303 (reduced).
Location: BL (2 copies: Harley 5915, nos. 453, 454 (2 fragments, 6 × 12 and 18 × 14 cm., lacking the border), reproduced in Johnson, *Selected essays*; Harley 5959, no. 14 (type area 26.3 × 15 cm.), reproduced in *Signature*, no. 3).

The description and measurement of this specimen in Reed-Johnson applies to the complete sheet (Harley 5959, no. 14), but the reference given there is to only one of the two fragments of the other copy (Harley 5915, no. 453).

P5 Anonymous c. 1700
[Specimen of printing types.]

1°. 29 × 17 cm. Reed-Johnson, p. 181.
Facsimile: Reed-Johnson, fig. 39; A. F. Johnson, *Selected essays* (Amsterdam, 1970), p. 310 (both reduced).
Location: BL (Harley 5915, no. 457).

P6 Anonymous c. 1770–80?
[Specimen of printing types.]

1°. 2 sheets. Simmons 1.
Location: OUP.

P7 Anonymous 1808
[Sale catalogue of printing materials, the property of 'a gentleman', Saunders, 18 May 1808.]

8°. 16 p.
Location: BL (Sale catalogues, Hodgson).

6 p. of type specimens.

P8 Anonymous 1813

[Sale catalogue of printing materials,
Saunders, 12 March 1813.]

8⁰. 13 p.
Location: BL (Sale catalogues, Hodgson).

9 p. of type specimens.

P9 Anonymous 1814

A catalogue of printing materials [etc.], the
genuine stock of a printer, bookseller &
stationer; removed from East-Lane,
Walworth. [Sale catalogue, Saunders,
8 July 1814.]

8⁰. 18 p., 4 leaves.
Location: BL (Sale catalogues, Hodgson).

4 leaves of type specimens.

P10 Anonymous 1816

A catalogue of printing materials consiting
of the most modern cut letter . . . 1,
Vineyard Walk, Clerkenwell . . . the
proprietor leaving the printing business.
[Sale catalogue, Saunders, 6 September
1816.]

8⁰. 5 p., 5 leaves.
Location: BL (Sale catalogues, Hodgson).

5 leaves of type specimens.

P11 Joseph Aston c. 1808?

A specimen of types & ornaments used in
the printing-office of Joseph Aston,
Exchange, Manchester.

8⁰. 20 p.
Location: SFPL.

Page 15 is a circular letter dated 'Man-
chester, July 10, 1808', set in script type.

P12 Benjamin Bensley c. 1830

A specimen of the types used by B. Bensley,
printer, Andover.

8⁰. 48 p. Berry & Johnson, p. 95.
Location: StB.

P13 William Bowyer c. 1740?

A specimen of the printing types of
W. Bowyer.

Location: LSE (MS. coll. G.1521, leaves
7–20).

Fragments apparently cut from a single
broadside specimen sheet. 64 types are
shown, set to a common measure of 8 cm.
They are pasted in a notebook containing
entries made between c. 1700 and 1802 in
the printing offices of Ichabod Dawks, the
elder and the younger William Bowyer, and
John Nichols.

P14 Anne Burton c. 1750

A specimen of letter to be dispos'd of by
Mrs. Anne Burton, in St. John's Lane,
Clerkenwell.

1⁰. Berry & Johnson, p. 89.
Location: Bodl.

P15 Cambridge University Press c. 1740

A specimen of the letters belonging to the
University of Cambridge.

1⁰. Berry & Johnson, p. 87.
Location: CUL.

P16 J. Clark 1822

Specimen of printing types, &c. in the
Newcastle Printing Office, Newgate Street.
J. Clark, printer. 1822.

8⁰. 59 leaves. Berry & Johnson, p. 94; Supp.
p. 38.
Location: Col.UL.

P17 John Dixcey Cornish 1770

A specimen of the printing types, cast by
William Caslon for the use of John Dixcey
Cornish, at number 4, in Printinghouse-
Yard, Black-Friars, London. MDCCLXX.

8⁰. 15 leaves. Reed, p. 256; Supp. p. 34.
Location: Ant.Soc.

P18 John Dillon 1799

A specimen of the beautiful collection of
printing types, cast by V. Figgins, of
J. Dillon, printer, 16, Plough Court, Fetter
Lane, Holborn, London: printed by
J. Dillon. 1799.

8⁰. 10 leaves.
Location: Soane.

P19 Glasgow University Printing Office 1826
Specimens of types, and inventory of
materials, belonging to the University
Printing Office of Glasgow; comprehending
all the apparatus necessary for conducting
the business of classical and English printing,
and stereotyping, on an extensive scale. The
whole establishment, with or without the
buildings and vacant ground, now offered
for sale, by private bargain.

8⁰. 4p., 17 leaves, 8 p.
Location: Gaskell.

17 leaves of type specimens. Folding plan
of 'the buildings & ground of the University
Printing Office, Villafield, Glasgow', dated
August 1826. The inventory of printing
materials without the specimens of type was
reprinted under the title *The Glasgow
University Printing Office in 1826* (Cambridge:
Water Lane Press, 1953).

P20 Joyce Gold 1823
Catalogue of the valuable book property,
extensive printing office, household
furniture, &c. of Mr. Joyce Gold, retiring
from business. [Sale catalogue, Saunders,
17–20 March 1823.]

8⁰. 8 p., 32 p. (sale of 19 and 20 Mar).
Location: BL.

31 p. of type specimens.
Gold registered printing materials at
103 Shoe Lane, London, from 1804 to
1823 (Todd).

P21 Johnson Gore 1819
Specimen of J. Gore's printing types, Castle-
Street, Liverpool. 1819.

8⁰.
Location: Barker (41 leaves); Harvard (39
leaves).

P22 Thomas Harper 1813
[Sale catalogue of printing materials,

Saunders, 12 March 1813, 'on the premises,
no. 4, Crane Court, Fleet Street'.]

8⁰. 13 leaves.
Location: BL (Sale catalogues, Hodgson).

9 leaves of type specimens. The identity of
the vendor is inferred from the address:
Thomas Harper registered printing mat-
erials at 4 Crane Court from 1807 to 1813
(Todd).

P23 G. F. Harris 1807
A specimen of the improved types of G. F.
Harris, printer, (successor to Mr. John
M'Creery,) Houghton-Street, Liverpool.

obl. 8⁰. 32 leaves. Berry & Johnson, p. 92;
Supp. p. 38.
Location: Amer.Ant.Soc; Col.UL; Wolpe.
Dated on printed wrapper, 25 Oct 1807.

**P24 Thomas Hart and William Strahan
c. 1740**
A specimen of the printing-letter of T. Hart
and W. Strahan, in Bury Court, Love-Lane,
Wood-Street.

1⁰. Berry & Johnson, p. 88.
Location: Col.UL.

P25 William Hay 177–?
A specimen of some of the printing types
belonging to W. Hay, printer, at his
printing office, adjoining to the British
Artists Exhibition Hall, near Exeter
Exchange, in the Strand: founded by the
most celebrated British letter-founders.
London: printed by W. Hay at his said
printing-office, where printing is carefully
expedited with accuracy, elegance, and
taste.

4⁰. 15 leaves. Berry & Johnson, p. 91.
Location: BL.

The BL catalogue entry suggests a date of
'1760?'. Berry & Johnson prefer 'c. 1780'
in their text, but the caption to their plate
21, which is Cottrell's Double Pica script
as shown in Hay's specimen, dates it
'c. 1768'. Maxted records Hay at the

address given in 1775, but at St Clement
Danes in 1776, and as a bankrupt, 1778.

P26 James Hedderwick and Son 1823
Reference book of James Hedderwick &
Son, printers, Melville-Place, Glasgow,
exhibiting the various sizes of printing types
with which their office is furnished. Britannia
Press. 1823.

4°. 64 p. Berry & Johnson, p. 94.
Location: StB; Wolpe.

P27 John Humfreys c. 1710
A specimen of the most useful sorts of
printing-letter, both roman and italick,
belonging to John Humfreys, printer, in
Bartholomew Lane, London.

1°. Berry & Johnson, p. 85.
Location: StB.

P28 G. F. Lamb 1822
A catalogue of printing materials; which
will be sold by auction. (by orders of the
trustees of Mr. G. F. Lamb of Reading.)
by Mr. Saunders, 17 September, 1822.

8°. 12 p.
Location: BL (Sale catalogues, Hodgson).

8 p. of type specimens.

P29 James Lister 176–?
A specimen of the Hebrew types of James
Lister, printer, St. John's Gate, Clerkenwell.

1°.
Location: StB.

P30 M. Mechell 1748
A specimen of printing-letter, belonging to
M. Mechell. At the King's Arms, the corner
of White-Fryers, opposite the Leg Tavern
in Fleet Street, August 13, 1748.

1°. Berry & Johnson, p. 89.
Location: Bodl.

P31 Hugh Meere c. 1710
Specimen. [At the foot of the second
column:] H. Meere, printer, at the Black-
fryar in Black-fryars, London.

1°. Berry & Johnson, p. 85.
Location: BL (Harley 5915, no. 460).

P32 John Moncur 1709
A specimen of the types in John Moncur's
printing-house; being a sermon on Jeremiah
50. verse 5 . . . Edinburgh printed by the
owner of the types, on the north side of the
Trone. MDCCIX.

8°. 7 leaves. Berry & Johnson, p. 86.
Location: StB.

P33 Edward Rowe Mores 175–?
Characteres Anglo-Saxonici per eruditam
faeminam Eliz. Elstob ad fidem codd. mss.
delineati. quorum tam instrumentis cusoriis
quam matricibus Univ. donari curavit
E. R. M. è Collegio Regin. A. M. 1753.

1°. Hart, pp. 81–3, 187; Berry & Johnson,
p. 8; Simmons 51; Mores, p. xxxix.
Facsimile: (2 states) Mores, pp. xl, xli.
Location: Bodl.; OUP; StB; Yale.

In 1753, William Bowyer expressed the wish
that the punches and matrices of the Elstob
Anglo-Saxon type should be given to the
University of Oxford. Some missing charac-
ters having been supplied and a small fount
cast, Mores had the punches, matrices and
type in his house from 1758 until 1764
(perhaps later) before handing them over
to the University (Mores, pp. xxv–xliii).
This specimen sheet, of which there are two
states (the heading quoted above being from
the fuller version at StB), was included by
Hart, and by Berry & Johnson following
him, among the specimens of the Oxford
University Press; but Mr Harry Carter
observes that 'it was almost certainly
printed by Edward Rowe Mores at a press
in his house, and the University had nothing
to do with it' (Hart, p. 187).

P34 Edward Rowe Mores 1781
A catalogue and specimen of sundry print-
ing material which will be sold by auction,
by Mr. Paterson, at his Great Room, (No.

6), King-Street, Covent-Garden, London
... November 20, 1781. ...

8º. 8 p. Berry & Johnson, p. 91; Mores,
p. lx.
Location: BL; StB.

P35 Benjamin Motte 1713

A specimen of B. Motte's printing-letter.
[At the foot of the last column:] January 1st
1712/13.

1º. Berry & Johnson, p. 85.
Location: BL (Harley 5927, nos. 346, 356);
CUL.

P36 James Moyes 1826

Specimens of the types commonly used in
the Temple Printing Office, Bouverie
Street; with their names, and the names of
the founders: also, specimens of wood
engravings. London: printed at the Temple
Printing Office, by J. Moyes, Bouverie
Street. M.DCCC.XXVI.

8º. 18 p., 13 leaves. Berry & Johnson, p. 95.
Location: BL; Col.UL; Newberry; OUP;
Prov.PL; Soane; StB.

See also Iain Bain, 'James Moyes and his
Temple Printing Office of 1825', *Journal of
the Printing Historical Society*, no. 4 (1968),
pp. 1–10.

P37 Observer of the Times 1823

A catalogue of the printing materials lately
used in printing 'The Observer of the
Times' Sunday newspaper. To be viewed
... at no. 25, Fleet-Street. [Sale catalogue,
Saunders, 27 February 1823.]

8º. 7 p.
Location: BL (Sale catalogues, Hodgson).

3 p. of type specimens.

P38 James Orme c. 1698

A specimen of Mr. J. Orme's printing-house
which is now to be disposed of; and part of
the house to be lett.

1º. Berry & Johnson, p. 84.
Facsimile: Reed-Johnson, fig. 40 (reduced).
Location: BL (Harley 5915, no. 38).

P39 William Henry Parker c. 1800

Specimen of W. H. Parker's printing types,
Broad Capuchin-Lane, Hereford.

1º. Supp. p. 38.
Facsimile: F. C. Morgan, 'Herefordshire
printers and booksellers', *Transactions of the
Woolhope Naturalists' Field Club* (Hereford,
1944), vol. for 1941, facing p. 110 (reduced);
'William Henry Parker's type specimens',
ibid., vol. 40 (1972), pl. 12 (reduced).
Location: Hereford CL (Davies Collection,
Collectanea Herefordensia vol. 46).

P40 William Henry Parker c. 1800

[Specimen of ornaments.]

1º. Supp. p. 38.
Facsimile: F. C. Morgan, 'William Henry
Parker's type specimens', *Transactions of the
Woolhope Naturalists' Field Club*, vol. 40
(1972), pl. 13 (reduced).
Location: Hereford CL (Davies Collection,
Collectanea Herefordensia vol. 46).

P41 John Reid 1768

A specimen of the printing types and flowers
belonging to John Reid, printer, Bailie
Fyfe's Close, Edinburgh. who performs all
kinds of printing-work, plain and ornamental,
in the neatest manner, and at the most
reasonable rates. N.B. the types are all
good; and the flowers entirely new, being
the completest collection anywhere to be
found. Edinburgh: printed by John Reid,
the proprietor. M DCC LXVIII.

8º. 12 leaves. Berry & Johnson. p. 90.
Location: StB.

See also D. J. Bryden, 'A short catalogue of
the types used by John Reid, printer in
Edinburgh, 1761–74', *The Bibliotheck*, vol. 6,
no. 1 (1971), pp. 17–21.

P42 Mary Reily 1766
A specimen of the printing-letter of Mrs. Mary Reily, deceased; which will be sold by auction, at the Sun-Tavern in Ludgate-Street, on Wednesday September 17, 1766
. . .

1⁰. Supp. p. 37.
Location: CUL.

P43 William Richardson c. 1765
A specimen of a new printing type, in imitation of the law-hand. Designed by William Richardson, of Castle Yard, Holborn.

1⁰. Bigmore & Wyman, ii, p. 256; Reed, p. 289; Berry & Johnson, p. 34.
Location: not known.

According to Bigmore & Wyman and to Reed, the type was Cottrell's 2-line Pica Engrossing.

P44 Thomas Rogerson 1817
A specimen of the printing types of Thomas Rogerson, printer, stationer, bookseller, and bookbinder, 21 Market Place, Manchester. Manchester: printed at the office of T. Rogerson, printer and publisher of the Manchester Almanack, Market Place. 1817.

8⁰. 24 leaves. Berry & Johnson, p. 93.
Location: StB.

P45 Thomas Rogerson 1819
A specimen of the printing types of Thomas Rogerson, printer, stationer, bookseller, and bookbinder, Market-Place, Blackburn. Blackburn: printed at the office of T. Rogerson, printer and publisher of the Manchester Almanack, Market-Place. 1819.

8⁰. 23 leaves. Berry & Johnson, p. 93.
Location: Col.UL.

P46 Samuel Rousseau 1814
A specimen and catalogue of the printing materials of Mr. Samuel Rousseau, at his office in Wood-Street, near the Spa fields,
Clerkenwell . . . which will be sold by auction, by James Delahoy, on Wednesday the 19th of January, 1814.
8⁰. 16 p.
Location: StB.

8 p. of type specimens.

P47 John Soulby 1809
Printing flowers. [At the foot:] Ulverston. 1809.

1⁰.
Facsimile: M. Twyman, *John Soulby, printer, Ulverston* (Reading, 1966), p. 25.
Location: Barrow PL.

P48 John Soulby c. 1810
Soulby's specimen of printing types. [At the foot:] J. Soulby, printer, Ulverston.

1⁰.
Facsimile: M. Twyman, *John Soulby, printer, Ulverston* (Reading, 1966), frontispiece (reduced).
Location: Barrow PL.

P49 Squire and Warwick 1811
[Sale catalogue of printing materials on the occasion of Squire and Warwick 'dissolving partnership', Saunders, 15 March 1811.]
8⁰. 8 p., 8 leaves.
Location: BL: (Sale catalogues, Hodgson).

8 leaves of type specimens.
Charles Squire registered printing materials at 7 Furnival's Inn Court, Holborn, in 1806–8. Squires [sic] and Warwick are recorded at the same address in 1810–11 (Todd).

P50 James Watson 1706
A specimen of the types in James Watson's printing-house. Being a sermon on Heb. ix. 27. Edinburgh: printed by the owner of the types, on the North-side of the Cross. MDCCVI.

4⁰. 13 leaves.
Location: NLS.

P51 James Watson 1713

Specimen of printing types in the printing-house of James Watson.

8°. 48 p., 1 folding sheet of ornaments. Berry & Johnson, p. 87; Simmons 59a. *Location:* BL; Col.UL; CUL (2 copies); Harvard (2 copies); Newberry; OUP; StB (2 copies); V&A.

In James Watson, *The history of the art of printing* (Edinburgh: printed by James Watson, 1713). Facsimile reprint, 1965.

P52 C. Wheeler and Son 1828

Specimen of types in the printing-office of C. Wheeler and Son, no. 7, Pall Mall, Manchester. MDCCCXXVIII.

8°. 71 leaves. Berry & Johnson, p. 96; Supp. p. 40.
Location: Col.UL.

P53 George Woodfall 1761

A specimen of the printing letter of Mr. George Woodfall, Charing Cross, who is leaving off that branch of business; with a catalogue of all his printing materials, which will be sold by auction on Monday, September 14th, 1761 at the Sun Tavern in Ludgate Street. To begin at seven o'clock.

4°. Caxton Celebration Catalogue, no. 4363; Berry & Johnson, p. 90.
Location: not known.

P54 Henry Woodfall 1747

A specimen of the printing letter of the late Mr. Henry Woodfall, without Temple Bar, London; with a catalogue of all his printing materials; which will be sold by auction on Monday, November 9th, 1747 at the Castle Tavern in Paternoster Row, to begin at four in the afternoon.

4°. Caxton Celebration Catalogue, no. 4362; Berry & Johnson, p. 88; Supp. p. 37.
Location: not known.

Appendixes

Appendix i

Works that draw attention to the types in which they are printed.

A1 William Bulmer and Co. 1803

Specimens of typography, without the use of balls; executed at the printing press lately invented by Earl Stanhope. London: printed by William Bulmer & Co. at the Shakespeare Printing Office, Cleveland Row. 1803.

4º. 4 leaves. Simmons 8.
Location: OUP; County Record Office, Maidstone, Kent (Stanhope Papers).

A2 Henry (or Henric) Fougt 1768

Six sonatas for two violins and a bass . . . compiled by Sigr. Francesco Uttini. London: printed and sold by Henry Fougt, at the Lyre and Owl, in St. Martin's-Lane, near Long-Acre.

4º. 16 p.
Location: StB.

The dedication to the Society for the Encouragement of Arts, Manufactures and Commerce, 18 October 1768, describes this as the 'first specimen of a New-invented Type for Printing Music'. Fougt's patent for the type is no. 888 of 24 December 1767. See also Mores, p. 76; Nils G. Wollin, *Det forste svenska stilgjuteriet* (Uppsala, 1943), pp. 82–125; Sten G. Lindberg, 'John Baskerville och Henric Fougt' and 'Henric Fougts engelska Musictryk', both in *Biblis* (Stockholm, 1958).

A3 John Walter 1785

Miscellanies in prose and verse, intended as a specimen of the types at the Logographic Printing Office. London: printed and sold by J. Walter, Printing-House-Square, Blackfryars, and at no. 45. Lombard-Street. 1785.

8º. xxiv, 226 p. Berry & Johnson, p. 56.
Location: BL; StB; etc.

The eight sizes of type in which the text is set are apparently: Great Primer, English, Pica, Small Pica, Long Primer, Bourgeois, Brevier (or Minion), and Pearl.

A4 Philip Rusher 1804

Rasselas, Prince of Abissinia, by Dr. Johnson. Printed with patent types in a manner never before attempted. Rusher's edition. Banbury: printed for P. Rusher, and sold by Mr. Budd, at the Crown and Mitre, Pall-Mall; Mr. Miller, 49 Albemarle-Street; Mr. Tegg, 111 Cheapside, London; and by Mr. J. Rusher, Reading. 1804. Cheney, printer, High-Street, Banbury.

8º. [iv], 136 p. Reed-Johnson, p. 111.
Location: StB.

Appendix ii

Works using the material of a named typefounder or punchcutter.

A5 William Caslon III 1789

The poetry of nature, comprising a selection of the most sublime and beautiful apostrophies, histories, songs, elegies, &c. from the works of the Caledonian bards. The typographical execution in a style entirely new, and decorated with the superb ornaments of the celebrated Caslon. [On the last page:] Londini. Typis J. P. Cooke.

4°. [xiii], 184 p. Reed-Johnson, p. 245, note 1; Birrell & Garnett 177.

Preliminary address dated 26 January 1789. The 'ornaments' referred to here are the cast ornaments of William Caslon III. The text is set in a Double Pica script type which Reed-Johnson and Birrell & Garnett attribute to Caslon III. However, it appears only in the specimens of the Salisbury Square foundry, and is therefore probably Jackson's.

A6 Edmund Fry 1790
C. Plinii Caecilii Secundi epistolarum libri X. Sumptibus editoris excudebant M. Ritchie & J. Sammells, Londini M.DCC.XC.

8°. 'Typis Edmundi Fry' (p. 484).

A7 Joseph Jackson 1786
Novum Testamentum Graecum è codice MS. Alexandrino qui Londini in Bibliothecâ Musei Britannici asservatur, descriptum a Carolo Godofredo Woide . . . Ex prelo Joannis Nichols. Typis Jacksonianis, 1786. Reed-Johnson, p. 316, note 1.

A8 Joseph Jackson 1790
Caii Julii Caesaris opera omnia. Sumptibus editoris excudebant Londini M. Ritchie & J. Sammells MDCC.XC.

8°. 2 vols. 'Typis Jacksonianis' (vol. 2, p. 391).

A9 Vincent Figgins 1796
Paradise Lost, by John Milton, with notes and life of the author . . . by Samuel Johnson, LL.D. Engravings by Heath, &c. London: printed for J. Parsons, 1796.

8°. 2 vols. The advertisement in vol. 1 refers to 'a new and beautiful Type cast on purpose for this work by Vincent Figgins'. Reed-Johnson, p. 330.

A10 Vincent Figgins 1797
The seasons, by James Thompson. Illustrated with engravings by F. Bartolozzi, R. A. and P. W. Tomkins, historical engravers to their Majesties; from original pictures painted for the work by W. Hamilton, R. A. London: printed for P. W. Tomkins, New Bond-Street. The letter-press by T. Bensley. The types by V. Figgins. MDCCXCVII.

2°.

A11 Vincent Figgins 1798
Quatuor evangelia Graece . . . edidit J. White. Oxonii: excudebat Samuel Collingwood, typis Vincenti Figgins. 1798.

8°.

A12 William Martin 1795
Poems by Goldsmith and Parnell. London: printed by W. Bulmer & Co. Shakespeare Printing Office, Cleveland-Row. 1795.

4°. 'The whole of the Types, with which this Work has been printed, are executed by Mr. William Martin' (Advertisement).

A13 Robert Perry 1752
A letter to the Rev. Mr. M---re B--k-r, concerning the Methodists. By a Country Gentleman. Dublin: printed for Peter Wilson, in Dame-Street. MDCCLII.

8°. On the verso of the title leaf is: 'This Letter was made by Mr. Perry, Letter-founder, in Dublin'.
Location: CUL (Bradshaw Collection).

A14 Robert Thorne 1814
The printer's price-book, containing the master printer's charges to the trade for printing works of various descriptions, sizes, types and pages; also a new, easy, and correct method of casting off manuscript and other copy, exemplified in specimen pages of different sizes and types . . . by C. Stower. London: printed by the editor, Hackney, for C. Cradock and W. Joy, Paternoster-Row. 1814.

8°. iv, 446 p.

Pp. 33–358 consist of specimen pages in types ranging in size from Brevier to English with different leading and measures. 'The types employed for these Specimens are

from the Foundery of Mr. Thorne, in Fan Street, Aldersgate Street' (p. 32).

Appendix iii

Specimens compiled for 'house' use

A15 John Nichols and Son 182–
[MS. title:] Specimen of the printing types of J. Nichols and Son.

61 p.
Location: BL (C. 124. e. 29.).

Pp. 2–38 have fragments of typefounders' specimens pasted on them, bearing dates from 1806 to 1825. The founders represented are W. Caslon, junr., V. Figgins, Fry and Steele, R. Thorne, and A. Wilson. The last 11 leaves show cast ornaments or wood engravings.

Appendix iv

Specimens of British types printed abroad.

A16 John Baskerville Kehl, 1782
Epreuves des caracteres de Baskerville. Juin, 1782.

8°. 35 leaves. Berry & Johnson, p. 31.
Location: BN.

A17 John Baskerville Paris, c. 1793
Essai d'épreuves des caractères de la fonderie de Baskerville. On travaille actuellement à la confection du specimen, ou livre d'épreuves de tous les objets que cette fonderie peut fournir. Cet essai ne contient que les fontes qui sont en nombre et prêtes à être livrées, au dépôt desdits caracteres, Porte St-Antoine, vis-à-vis les ruines de la Bastille, entre la rue Amelot et le Boulevard. S'adresser au Citoyen Colas, audit dépôt; ou à sa demeure, rue St-Antoine, près la place de la Liberté, no 161.

8°. 19 leaves. Berry & Johnson, p. 31; Supp. p. 35.
Location: BL; Col.UL.

See John Dreyfus, 'The Baskerville punches 1750–1950', *The Library*, 5th series, vol. 5 (1950–51), pp. 26–48.

Appendix v

Specimens of engraved brass printers' ornaments.

A18 Richard Brook 1804
A specimen of brass ornaments on an improved principle, for letter-press printing, by Richard Brook, engraver to His Majesty and His Royal Highness the Duke of Kent, no. 302, Strand, London. A large and elegant assortment of bookbinders brass ornaments for sale. Maps, charts, bankers cheques, shop cards, and bills of every kind, engraved and printed. Engraving on wood. London. Printed by Thomas Collins, Harvey's Buildings, Strand. 1804.

8°. 7 leaves.
Location: Amer.Ant.Soc.

A19 Cornelius and Abraham Paas 1788
A specimen of brass card borders, on an entire new principle, by C. & A. Paas, engravers to their Majesties. London printed by T. Rickaby. M.DCC.LXXXVIII.

8°. 16 leaves. Berry & Johnson, p. 57.
Facsimile: ed. J. Mosley, 1965.
Location: StB.

A20 Cornelius and Abraham Paas 1793
Specimen of brass card borders, and other ornaments, on an entire new principle, by C. & A. Paas, engravers to their Majesties. London printed by T. Bensley. 1793.

8°. 40 p. Berry & Johnson, p. 57.
Location: Amer.Ant.Soc.

Appendix vi

Typefounders' sale catalogues without specimens of type.

A21 Anthony Bessemer 1832
'In 1832 he retired from the business, and his foundry was put up to auction and dispersed. The Catalogue of the Sale mentions that the 2,500 punches included in the plant had been collected at an expense of £4,000, and that not a single strike had been taken from them but for the proprietor's own use. From a marked copy of the catalogue in our possession, it appears that several of the lots of punches and matrices fetched high prices.' (Reed, p. 359.) Neither Reed's nor any other copy of this sale catalogue is known to survive.

A22 Henry Bower 1851
Catalogue of the entire and valuable plant, tools, and stock of that highly celebrated and old established type foundry, belonging to the estate of the late Mr. Henry Bower, deceased, comprising about fifty thousand punches and matrices, and suitable moulds; together with the working tools & utensils of trade; also a large quantity of manufactured stock; which will be sold by auction, by Mr. Walker, on the premises, The Nursery, Sheffield, on Monday, the 22nd day of September, 1851, and the following days of business. [At the head:] Sheffield type foundry. Without reserve.
8°.
Location: StB.

A23 Caslon Letter Foundry 1846
To capitalists. Particulars of a most valuable property for investment, called the Caslon Letter Foundry, containing the original works of its founder, William Caslon, which have been recently much in request for reprints; also a most extensive modern foundry . . . which will be sold by auction, by W. Lewis and Son . . . on the premises,

Chiswell Street, Finsbury Square, on Wednesday, December 16, 1846.
2°. 12 p.
Location: StB.
Contains an inventory of the 'contents of the modern foundry' (i.e. types cut after about 1795), identifying the cutter of each type. The reserve price was not reached at the sale, and the foundry continued in business. See Reed-Johnson, pp. 250–1.

A24 Edmund Fry 1828
In 1828 Fry issued a circular 'enumerating generally the contents of the foundry and stating the conditions of sale' (Reed, p. 310). Reed quotes extensively from the historical note that accompanied it but not from the list of contents. It was dated from the 'Polyglot Letter Foundery, 2nd month 14th, 1828'. No copy is known.

A25 Louis Jean Pouchée 1830
'In the beginning of 1830 he abandoned the business, which was sold by auction. The catalogue included a large quantity of stereotype ornaments, as well as 20,000 matrices and punches, moulds, presses, and 35 tons of Type. The lots were variously disposed of at low prices among the other founders.' (Reed, p. 362.) No copy of the catalogue is known.

A26 Simon and Charles Stephenson 1797
A catalogue of the stock in trade and all the genuine punches, matrices, moulds, and other materials, tools, and implements of the British Letter-Foundry, in Breams-Buildings, Chancery-Lane, London. Hitherto carried on under the firm of S. and C. Stephenson, (the partnership being dissolved by mutual agreement;) which will be sold by auction by Mr. C. Heydinger; at the Navy Coffee-House, Newcastle-Street near the new church, Strand, on Monday evening, November 27, 1797, at six o'clock precisely. To be viewed on the premises,

from Tuesday to Friday preceeding the sale; when catalogues will be delivered on the premises, at the place of sale, and by Mr. C. Heydinger, no. 13, Plumtree-Street, Bloomsbury.

8°. 12 p.
Location: StB.

A27 Robert Thorne 1820
Particulars of the lease and valuable plant of the type foundery of Mr. Robert Thorne, deceased, situate in Fann's Street, Aldersgate Street, . . . which will be sold by auction by Mr. W. Davies, at Garraway's Coffee House, on Wednesday, the 21st of June, 1820, at twelve o'clock, in one lot.
The contents are summarized by Reed, p. 295 (Reed-Johnson, p. 294). The location of the original is unknown.

Chronological list of specimens

An asterisk * indicates a specimen
with no present location

c. 1650
 Anonymous **P2**

c. 1665
 Nicholas Nicholls **167, 168**

1669
 Joseph Moxon **166**

c. 1687
 Oxford University Press **169**

c. 1690
 Grover foundry? **141**

1693
 Oxford University Press **170**

1695
 Oxford University Press **171**

1698
 Heirs of Andrew Anderson **P1**

c. 1698
 James Orme **P38**

c. 1700
 Anonymous **P3–5**
 Robert Mitchell **161**

1706
 Oxford University Press **172**
 James Watson **P50**

1709
 John Moncur **P32**

c. 1710
 John Humfreys **P27**
 Hugh Meere **P31**

1713
 Benjamin Motte **P35**
 James Watson **P51**

c. 1730
 William Caslon **34**

before 1734
 William Caslon **35**

1734
 William Caslon **36**

'1734' (actually 1738–52)
 William Caslon **37**

c. 1740
 William Bowyer **P13**
 Cambridge University Press **P15**
 William Caslon **38**
 Thomas Hart and William
 Strahan **P24**

1742
 William Caslon **39**

c. 1742
 William Caslon **40**

1746
 William Caslon and Son **41**

1747
 Henry Woodfall **P54***

1748
 William Caslon and Son **42**
 John James **148***
 M. Mechell **P30**

1749
 William Caslon and Son **43**

c. 1750
 Anne Burton **P14**

175–?
 John Baine **4***
 Edward Rowe Mores **P33**

before 1752
 William Caslon and Son **44***

1753
 George Anderton **1***

1754
 John Baskerville **6**

1757
 John Baskerville **7**

1757–8
 Oxford University Press **173**

c. 1760
 John Baskerville **8**

176–?
 Thomas Cottrell **86-9**
 James Lister **P29**

between 176– and 1785
 Thomas Cottrell **90**

1761
 George Woodfall **P53***

from c. 1762
 John Baskerville **9, 10**

1763
 William Caslon and Son **45**

1764
 William Caslon and Son **46-8**

c. 1765
 Joseph Jackson **144***
 William Richardson **P43***

1766
 William Caslon II **49**
 Isaac Moore and Co. **163**
 Mary Reily **P42**

1768
 Isaac Moore and Co. **163**
 Oxford University Press **174**
 John Reid **P41**

1769
 Stephen Parker **179**

1770
 William Caslon II **50**
 John Dixcey Cornish **P17**
 Thomas Cottrell **91**
 Isaac Moore and Co. **164***
 Oxford University Press **175**

177–?
 William Hay **P25**

c. 1770–80?
 Anonymous **P6**

1772
 Alexander Wilson and Sons **211**

1773?
 Joseph Jackson **145**

c. 1774–8
 William Caslon II and Son
 51, 52

1775
 John Baskerville **11**
 Oxford University Press **176**

1777
 Sarah Baskerville **12**

1778
 Joseph Fry and Co. **105**

1780
 William Caslon III 53
 Joseph Fry and Co. 106

c. 1780
 Robert Martin 151

1781
 Edward Rowe Mores P34

1782
 John James 149

1783
 Alexander Wilson and Sons 212

1784
 William Caslon III 54*

1785
 William Caslon III 55, 56
 Joseph Fry and Sons 107, 108

c. 1785?
 Joseph Jackson 146, 147
 Joseph Moore 165

1786
 William Caslon III 57, 58
 Joseph Fry and Sons 109
 Oxford University Press 177
 Alexander Wilson and Sons 213

1787
 John Baine and Grandson
 in Co. 5
 Edmund Fry and Co. 110, 111

1788
 John Bell 13
 Edmund Fry and Co. 112

1789
 Bell and Stephenson 15
 Alexander Wilson and Sons 214

c. 1789
 John Bell 14

1790
 Edmund Fry and Co. 113, 114
 Simon Stephenson 187

c. 1790
 Edmund Fry and Co. 115*
 Myles Swinney 191

1791
 Simon Stephenson 188

1793
 Vincent Figgins 92
 Edmund Fry and Co. 116

c. 1793
 Edmund Fry and Co. 117

1794
 Fry and Steele 118, 119
 Oxford University Press 178
 Robert Thorne 193

1795
 William Caslon III 75, 76
 Fry and Steele 120

1796
 William Caslon III 77
 Simon and Charles Stephenson
 189, 190

1796–9
 Elizabeth Caslon 59

1798
 William Caslon III 78, 79
 Fry, Steele and Co. 121
 Robert Thorne 194

1799
 John Dillon P18
 Fry, Steele and Co. 122

1800
 William Caslon III 80
 Caslon and Catherwood 60
 Fry, Steele and Co. 123

c. 1800
 William Henry Parker P39, P40

1801
 Vincent Figgins 93
 Fry, Steele and Co. 124

1802
 Vincent Figgins 94
 Fry, Steele and Co. 125
 Myles Swinney 192

c. 1802
 Vincent Figgins 95

c. 1802–5
 Caslon and Catherwood 61

1803
 William Caslon III and Son 81
 Fry, Steele and Co. 126
 Robert Thorne 195

1804–10
 Fry and Steele 131

1805
 Caslon and Catherwood 62
 Fry and Steele 127

after 1805
 Caslon and Catherwood 63

1806
 Fry and Steele 128
 Robert Lothian 150

1807
 G. F. Harris P23

1808
 Anonymous P7
 Caslon and Catherwood 64
 Fry and Steele 129, 130

c. 1808
 Joseph Aston P11
 William Caslon IV 82*, 83*
 Caslon and Catherwood 65*

1809
 William Miller and Co. 153*
 Slater, Bacon and Co. 186
 John Soulby P47

1810
 Bower, Bacon and Bower 30
 Robert Thorne 196

c. 1810
 John Matthewson 152
 John Soulby P48

1811
 William Miller and Co. 154
 Squire and Warwick P49

1812
 Alexander Wilson and Sons 215

1813
 Anonymous P8
 Bower, Bacon and Bower 31
 Thomas Harper P22
 William Miller and Co. 155

c. 1813
 Robert Thorne 197

1814
 Anonymous P9
 Fry and Steele 132
 William Miller and Co. 156
 Samuel Rousseau P46
 Robert Thorne 198*

c. 1814–16
 Fry and Steele 133

c. 1814–17
 Alexander Wilson and Sons 217

1815
 Caslon and Catherwood 66
 Vincent Figgins 96
 William Miller and Co. 157
 Alexander Wilson and Sons 216

c. 1815
 Robert Thorne 199*

1816
 Anonymous P10
 Caslon and Catherwood 67
 Edmund Fry 134

c. 1816
 William Caslon IV 84

1817
 Vincent Figgins 97
 Thomas Rogerson P44

1819
 Richard Austin 3
 William Caslon IV 85
 Caslon and Catherwood 68*
 Johnson Gore P21
 Louis Jean Pouchée 180
 Thomas Rogerson P45

c. 1819
 Blake, Garnett and Co. 20

1820
 Edmund Fry and Son 135
 William Thorowgood 200*

1821
 Anthony Bessemer 16
 Blake, Garnett and Co. 21
 Caslon and Catherwood 69
 Vincent Figgins 98
 Pouchée and Jennings 181
 William Thorowgood 201

1822
 Anthony Bessemer and John
 Caslon and Livermore 70
 James Catherwood 17
 J. Clark P16
 G. F. Lamb P28
 William Miller 158, 159
 Pouchée and Jennings 182
 William Thorowgood 202, 203*

1823
 Edmund Fry and Son 136
 Joyce Gold P20

James Hedderwick and Son P26
 Observer of the Times P37
 Pouchée and Jennings 183
 Alexander Wilson and Sons 218

after 1823
 Hugh Hughes 142, 143*

1824
 Vincent Figgins 99
 Edmund Fry 137
 William Thorowgood 204

c. 1824
 Vincent Figgins 100

1825
 Anthony Bessemer and John
 James Catherwood 18
 Edmund Fry 138
 Matthew Urlwin Sears 185
 William Thorowgood 205

c. 1825
 Caslon and Livermore 71

1826
 Augustus Applegath 2
 Blake, Garnett and Co. 22
 Bower, Bacon and Bower 32
 Vincent Figgins 101
 Glasgow University Printing
 Office P19
 James Moyes P36
 Alexander Wilson and Sons 219

1827
 Blake, Garnett and Co. 23–5
 Caslon and Livermore 72
 Vincent Figgins 102
 Edmund Fry 139
 Louis Jean Pouchée 184
 William Thorowgood 206

1828
 Blake, Garnett and Co. 26
 Vincent Figgins 103
 Edmund Fry 140
 William Thorowgood 207
 C. Wheeler and Son P52
 Alexander Wilson and Sons 220

1829
 Caslon and Livermore 73
 William Thorowgood 208

1830
 Anthony Bessemer 19
 Blake and Stephenson 29
 Blake, Garnett and Co. 27
 Bower and Bacon 33
 Caslon and Livermore 74
 Vincent Figgins 104
 William Thorowgood 209, 210*

c. 1830
 Benjamin Bensley P12
 Blake, Garnett and Co. 28
 William Miller 160*

Places of issue other than London

Index

Anderson, Andrew, heirs of.
Printers, Edinburgh. Specimen:
1698, **P1**. For an account of the
printers trading under this
name, see James Maclehose,
*The Glasgow University Press
1638–1931* (Glasgow, 1931),
pp. 39–55.

Anderton, George. Typefounder,
Birmingham. Specimen: 1753,
1*.

Applegath, Augustus (1788–
1871). Printing machinery
manufacturer, printer and
typefounder, London. Speci-
men: 1826, **2**.

Arabic and Persian Press see
Rousseau, Samuel.

Aston, Joseph. Printer, Man-
chester. Specimen: c. 1808?,
P11.

Austin, Richard. Punchcutter,
wood-engraver and type-
founder, London. Established
Imperial Letter-Foundery
c. 1815 (Todd). Specimen:
1819, **3**. See also **13, 14, 187,
188, 190**. Stanley Morison,
*Richard Austin, engraver to the
printing trade between the years
1788 and 1830* (Cambridge,
1936).

**Austin's Imperial Letter-
Foundery** see **Austin,
Richard.**

Baine, John. Typefounder,
London and Edinburgh. A
partner with **Alexander
Wilson** in setting up a foundry
at St Andrews in 1742. Partner-
ship dissolved 1749. Set up
foundry of his own in London.
Specimen: 175–?, **4***. Later
moved back to Scotland.
Formed partnership with his
grandson, John Baine.

**Baine, John and Grandson
in Co.** Typefounders, Edin-
burgh. Partnership of **John**

Baine and his grandson John
Baine. Specimen: 1787, **5**. Both
Baines emigrated to Philadel-
phia in 1787 (Rollo G. Silver,
*Typefounding in America 1787–
1825* (Charlottesville, 1965),
pp. 3–9.)

Baskerville, John (1706–75).
Printer and typefounder,
Birmingham. Specimens: 1754,
6; 1757, **7**; c. 1760, **8**; from c.
1762, **9, 10**; 1775, **11**. His widow
Sarah Baskerville continued
the business briefly after his
death.

Baskerville, Sarah. Printer and
typefounder, Birmingham.
Widow of **John Baskerville**.
Specimen: 1777, **12**. Sold the
materials of the foundry to
Caron de Beaumarchais in
1779. Later specimens of the
Baskerville types: 1782, **A16**;
c. 1793, **A17**.

Bell, John (1745–1831). Printer,
publisher and typefounder,
London. Established his British
Letter Foundry 1787. Speci-
mens: 1788, **13**; c. 1789, **14**.
Took Simon Stephenson into
partnership 1789, trading as
Bell and Stephenson. Stanley
Morison, *John Bell* (London,
1930).

Bell and Stephenson. Type-
founders, London. Partnership
of **John Bell** and **Simon
Stephenson**. Specimen: 1789,
15. Partnership dissolved Dec
1789. **Simon Stephenson**
continued the business.

Bensley, Benjamin. Printer,
Andover. Specimen: c. 1830,
P12.

Bessemer, Anthony (born
1766). Typefounder, Hitchin
and London. Born in London,
and lived for a time in Holland,
then France, where he worked

in the foundry of P. F. Gando.
On his return to England, cut
punches for the Caslon foundry,
Chiswell Street. Established
his own foundry at Hitchin,
Herts. Specimen: 1821, **16**.
Formed partnership with **John
James Catherwood**, trading
as

**A. Bessemer and J. J.
Catherwood.** Specimens:
1822, **17**; 1825, **18**. After the
dissolution of the partnership,
perhaps by the death or retire-
ment of Catherwood, the
foundry moved to London,
trading again as

A. Bessemer. Specimen:
1830, **19**. At Bessemer's retire-
ment in 1832 the foundry was
sold at auction. Sale catalogue,
A21*. Forty-four of Bessemer's
types are listed in the Caslon
sale catalogue of 1846, **A23**.

Bessemer and Catherwood
see **Bessemer, Anthony.**

Blake and Stephenson. Type-
founders, Sheffield. Formerly
Blake, Garnett and Co. The
firm adopted this style in 1830.
Specimen: 1830, **29**. In 1841 it
became Stephenson, Blake and
Co. Sydney Pollard, unpub-
lished history of Stephenson,
Blake and Co. Ltd., c. 1960;
Roy Millington, Printing types
of the Stephenson, Blake letter
foundry, Sheffield, 1796 to
1846, MA dissertation, Shef-
field, University, 1974.

Blake, Garnett and Co. Type-
founders, Sheffield. A partner-
ship set up in Sheffield in July
1818, consisting of James
Blake, a file manufacturer;
William Garnett, a silversmith
by training, who had worked
with the foundry of **Bower,
Bacon and Bower** making